BRITAIN IN OLD PH

C000260818

MIDDLESBROUGH
PAST & PRESENT

PAUL MENZIES

The History Press

I would like to dedicate this book to Jackie, Andy and Dave, and the late Sally Menzies

First published 2011

The History Press
The Mill, Brimscombe Port
Stroud, Gloucestershire, GL5 2QG
www.thehistorypress.co.uk

© Paul Menzies, 2011

The right of Paul Menzies to be identified as the Author
of this work has been asserted in accordance with the
Copyrights, Designs and Patents Act 1988.

All rights reserved. No part of this book may be reprinted
or reproduced or utilised in any form or by any electronic,
mechanical or other means, now known or hereafter invented,
including photocopying and recording, or in any information
storage or retrieval system, without the permission in writing
from the Publishers.
British Library Cataloguing in Publication Data.
A catalogue record for this book is available from the British Library.

ISBN 978 0 7524 5795 6

Typesetting and origination by The History Press
Printed in Great Britain

CONTENTS

About the Author 5

Acknowledgements 6

Introduction 7

1 Now Where is That? 9

2 'Mam went every Saturday' 32

3 When Men Worked Hard 48

4 Suburban Dream 57

5 Some Highlights 83

6 When Suburbs were Villages 91

Bibliography 96

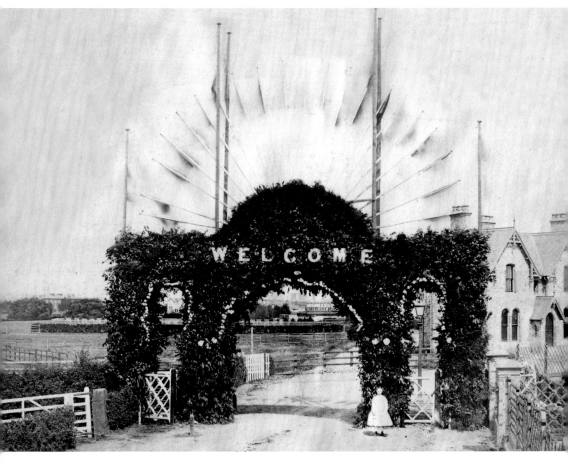

This image, one of several taken when HRH Prince Arthur visited the town in August 1868, is unique, giving a glimpse of Middlesbrough's pre-industrial past. Look beyond the decorative gate at Marton Grove and you can see hedgerows and fields, the farmland that later became the housing estates at Grove Hill. Prince Arthur came to open Albert Park.

ABOUT THE AUTHOR

Paul Menzies has written and broadcasted extensively on the Teesside region over the past twenty-five years, and has long family associations with the town of Middlesbrough. He has been the historical advisor on a number of projects, including Granada Television's *In Suspicious Circumstances*, starring the late Edward Woodward. He runs Image North East; a company dedicated to preserving the history and heritage of the region, and in 2010 was invited to write for the BFI's new regional Mediatheque project in Newcastle.

ACKNOWLEDGEMENTS

I give grateful thanks to all those individuals and organisations that have allowed me to copy and use their material, given of their time and generally helped in my research. I have taken a great deal of time to trace and establish ownership of all material, ensuring that permission for reproduction in this work has been given, whether in copyright or not. Other material is from the author's own collection.

Of course, it goes without saying that a work of this nature would not come to fruition without contributions from many other sources. These include: my maternal grandfather, the late John Lindberg, whose tales of Middlesbrough before the First World War are now preserved on tape forever; the late Wilf Mannion; Len Whitehouse; Revd W. Wright, the now defunct Cleveland County Council Planning Department; Mark Rowland-Jones and Jo Faulkner at Stockton Museum Service; Alan Sims at the *Evening Gazette*; the staff at Middlesbrough Reference Library, particularly Larry Bruce back in the 1980s; David Tyrell, Janet Baker, Stuart Pacitto, Anne Hill and Debbi Stalwarts of Teesside Archives, without whose kindness and patience this have book would not been possible; Steve Wild at Stockton Library; Jeff and Vera Wilkinson; Bill Bandeira and Steve Hearn at the Ordnance Survey; and, of course, Matilda Richards at The History Press, who has offered such good support during the writing of this work. If there are any unmentioned sources here, I offer my grateful thanks, as well as my apologies for failing to mention them by name.

Similarly, whilst I have attempted to ensure that there are no obvious mistakes in this work, I would like to apologise in advance for any errors that have been made, factual or otherwise. Please let me know of any errors and I will update my records. In the same vein, if anyone has any more information or evidence about any aspect of the history of Middlesbrough that they would like to share with me, please get in touch, especially if you have any images that you will allow me to copy. With computer technology they can be copied in minutes and, in the case of damaged material, they can even be restored to a better state than the original print! I have been pleased to provide digitally-restored images for a number of people. Also, in digitally preserving these images, they are being saved in a form where they will not deteriorate.

Writing, of any nature, always impacts on those people closest to you and this is the case here. I would like to offer an enormous thank you to my dear wife Jackie, who has had to put up with many months of my rising at five o'clock in the morning to write, before going off to work, as well as many rainy afternoons spent in Middlesbrough's libraries.

INTRODUCTION

This was a very different type of book for me to write, as I normally only comment on images of the past; to be asked now not only to photograph the present but also to compare past with the present was a new challenge. Yet it was immensely enjoyable and opened my eyes to some of the changes that have taken place in Middlesbrough.

I have always thought myself very fortunate to be born in 1953. This has meant I have been able to enjoy, to the full, the current 'gadget age', and use it daily in all aspects of my work. However, as a historian, I am very thankful that as a child I was able to walk hand-in-hand with my mother, who was born and bred in Middlesbrough, and see at first hand the Victorian heritage of the town. You see they hadn't started to knock it all down then. There were still gas lamps and dark, dingy streets around the town centre. The whole of Cannon Street was still a thriving community and much of the old town by the river was still largely intact. As we crossed the Newport Bridge on the bus to visit my grandparents, I recall looking from the window across to the iron and steel works at Newport – it was like Dante's inferno as bright orange flames licked the sky. There seemed to be thousands of houses too, each with their own tiny chimney and a wisp of dark-grey smoke curling its way skywards. There was pollution then; it was everywhere, but we didn't realise we had pollution – it was just smoky and grimy.

I remember going down Newport Road, a tightly-knit community with a multitude of shops along the full stretch of the road. There were also the buildings around the Exchange Bus Station, and the tiny tobacconist's in the centre that also sold sweets. Many times I ran across to this smokers' haven to get a bar of chocolate – a reward from my mother for not complaining too much when waiting for the bus. We seemed to do a lot of waiting then; waiting in the cold wind that always seemed to blow. As the sun went down on dark winter afternoons, the horse-chestnut man always seemed to be stood in Wilson Street and we bought a bag of chestnuts, which we then juggled about from hand-to-hand until they cooled down. On good days he sold pikelets and we bought them to eat when we reached home.

Now, as I have photographed the town over the past year, I realise how much it has changed; incredulously, the traditions that I once took for granted have all gone. I wonder whatever happened to the horse-chestnut man, or the grumpy bus conductor who used to shout, 'Fares please, come on move down the bus, seats upstairs...', as the bus ploughed its way through puddles on wet evenings. I know what happened to the buildings; they have all gone – vanished, just simply vanished. It is amazing how many buildings and structures that were part of the history of Middlesbrough have been erased from the landscape. Thousands of terraced streets have disappeared without trace, almost as if they were never there.

Look across from the Newport Bridge to Newport and you now see green fields. Yes, green fields for the first time in 200 years! The transformation, from the place that exemplified Victorian enterprise to the modern University town of today, is little short of a miracle.

I am not saying that it has all been done well; as with most endeavours, there have been successes and failures. The town has embraced the twenty-first century with real energy; the shopping facilities are second to none and the new football stadium is a triumph of forethought and design. But who destroyed Victoria Square, and did we have to pull down the Middlesbrough Exchange?

Whatever your views, there is no doubt that Middlesbrough has changed. My grandfather, born here in 1900, saw very little demolition of old Middlesbrough in his first fifty years of life. Yet my mother, who died in 1966, would, less than fifty years later, recognise hardly any of central Middlesbrough. Well, she would pick out the Town Hall and the Empire, and see that some of Albert Road still stands, but whatever happened to the Corporation Hotel, Cannon Street, Newport Road, the 'F' bus – and what exactly is the Cleveland Centre, or The Mall as it is called today?

I could go on, but I'll let the book do the talking from here onwards. I know from my emails and letters that these books go across the world. To those of you who are elsewhere in the world when you read this, I hope you enjoy your trip back home, seeing the town as it once was (probably as it was when you lived here), and as it is now. For those who still connect with Middlesbrough on a regular basis, accept this as a record of what has changed, including some changes you may not yet have noticed!

Paul Menzies, 2011
m.menzies1@ntlworld.com

1

NOW WHERE IS THAT?

The past is always around us, even if we don't recognise it…

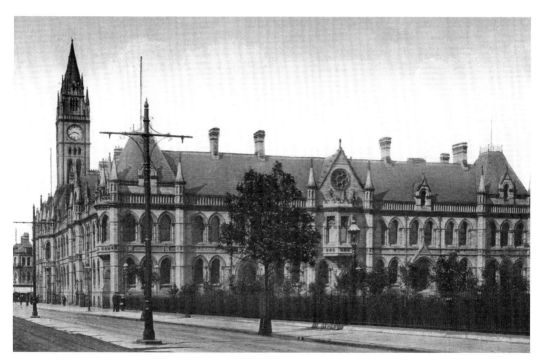

The dignitaries on Middlesbrough Council in 1889 regarded the rise of their town as a remarkable example of Victorian enterprise, and the building of their new Town Hall marked the culmination of this civic pride. This wonderful Gothic structure, opened on 23 January 1889 by the Prince and Princess of Wales, was a seal of royal approval for the phenomenal achievements of the town, rising, as it had done, from the green fields of Middlesbrough Farm to a town known throughout the world for its association with industry. Despite the demise of much local industry, there is still a great deal of civic pride and affection for the Town Hall today; a recent programme of renovation will ensure its preservation for many years to come.

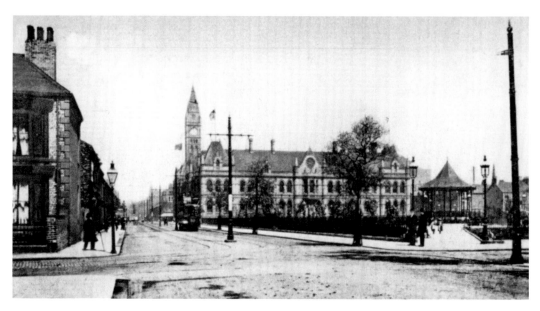

This view from the junction of Grange Road West and Albert Road (*c.* 1908) shows the Town Hall and the adjoining municipal buildings. A tram passes Victoria Square, which was opened in 1901 having been built on land previously used as a cattle market, circus, cycle track and occasional skating rink. Victoria Square quickly became a popular facility for townspeople, many of whom lived in the nearby terraced rows of houses that characterised the centre of town. On the left, in the foreground, we can just glimpse a house on Grange Road West – considerably larger than the nearby houses located on Albert Road.

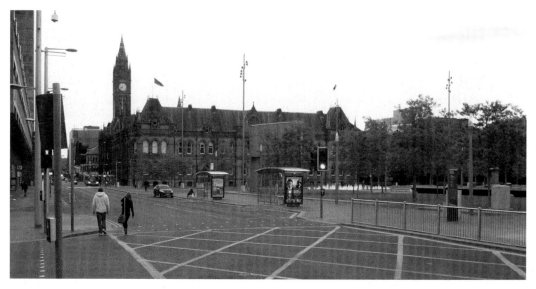

More than a hundred years later, the Town Hall is still an outstanding building. Victoria Square remains as an open space, but the scene has changed dramatically. The grass areas and the ornate bandstand in Victoria Square have all gone – replaced by high-tech fountains, programmed to emit a pattern of gushing sprays of water. Trees flank a large television screen showing the BBC News channel. It's all very minimalist, the clean-cut design contrasting with the elegance of a century ago. Opposite is the Cleveland Centre (now The Mall), a modern retail development – the result of the demolition of so many streets and houses in the early 1970s, when it was built.

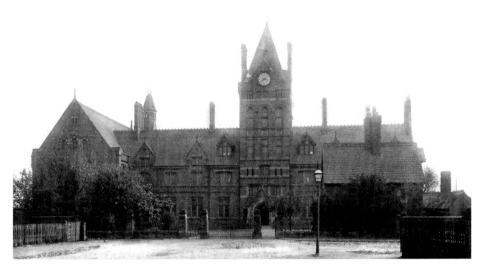

One of the town's leading schools, Middlesbrough High School (for boys), at No. 1 Grange Road, was founded by a group of local industrialists on 15 October 1870. Initially, twenty-five fee-paying pupils were enrolled, but by 1874 numbers had increased to ninety-three. A school for girls had also opened, on 11 August 1874, at No. 37 Grange Road, aided by a grant from local ironmaster Bernard Samuelsson. When a preparatory school was added in 1876, it became clear that a more substantial building was needed. A site at the southern end of Albert Road, occupied by allotments, was offered by J.W. Pease and his partners. The new buildings, designed by the Gothic-revivalist architect Alfred Waterhouse, opened on 15 January 1877. The clock tower, familiar to generations of schoolchildren, is seen here in 1896 together with the buildings that surrounded it.

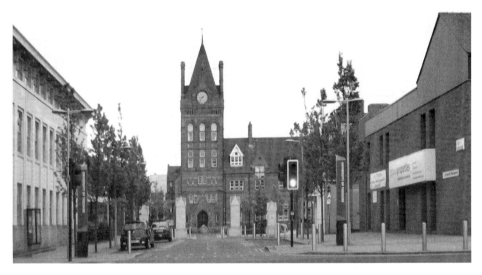

Today, the site is part of the University of Teesside. It is pleasing to see that the view is still recognisable, although somewhat changed. The clock tower and the western section still stand, monuments from the past now dwarfed by the huge, modern University edifice only yards away. The original school building, which closed in 1959, was cut in half a decade later, when the eastern section of the school was demolished during development of the Further Education buildings. Buildings around the site have also gone, although the white stone building on the left, for many years part of Constantine College and opened by the Prince of Wales (later Edward VIII) on 2 July 1930, has survived.

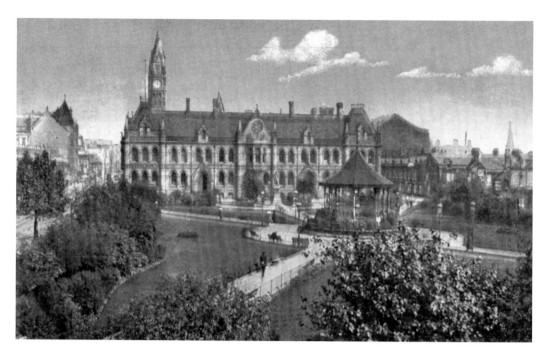

Many pupils attending Hugh Bell School, in central Middlesbrough, will have looked dreamily through the classroom window to this view of the trees and bushes of Victoria Square. The Town Hall, Municipal Buildings and terraced houses in Dunning Street and Russell Street could all be seen, as well as the many seats in the Square, often occupied by older people from the town who liked nothing better than to sit there and watch the world pass them by.

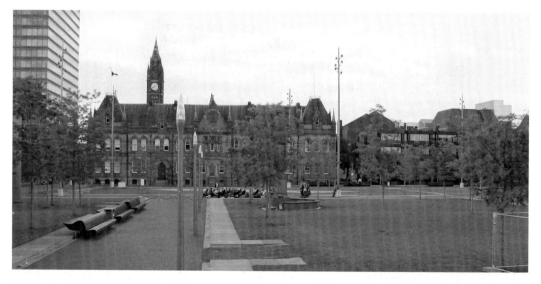

Today, you have to stand on the entrance steps of Teesside Law Courts to obtain the same view. The Gothic structure of the Town Hall is largely unchanged, but Victoria Square has been completely redesigned. There are still seats here but no bushes or flowerbeds; instead there are rectangles of grass, flanked by grey brick pavements. The atmosphere feels quite bleak, especially when contrasted with the glorious colours the gardens offered in the past.

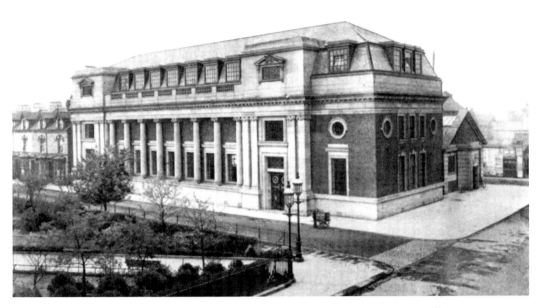

A generous donation of £15,000 from Andrew Carnegie, in January 1908, enabled the Carnegie Library (as it was originally known), to be built on land donated by Sir Hugh Bell on Grange Road and by Amos Hinton on Dunning Street. Shown here from the south-west, shortly after being opened by Alderman Amos Hinton on 8 May 1912, the new building replaced the Free Library, which had been housed in rooms at the Town Hall on the corner of Russell Street and Albert Road.

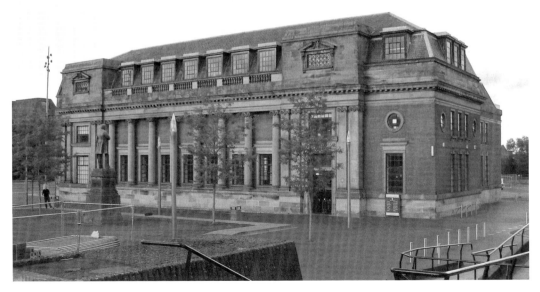

Nearly a century later, the library (renamed Middlesbrough Central Library) remains a popular facility. The building is very familiar, but the surrounding landscape is significantly different, with all traces of previous buildings gone. This view from the steps of Teesside Law Courts takes in the library and the edge of the Victoria Square development.

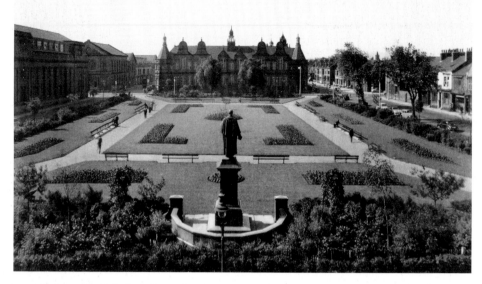

This image is from 1959, before the re-development of the town centre began in earnest. At that time, many buildings from Victorian Middlesbrough were still in existence, although many were shabby, due to the pollution of local industry reeking havoc on exterior facades. This image from the Town Hall looks across to Hugh Bell School and the United Methodist Chapel on the corner of Grange Road and Dunning Street. Both buildings have now gone, the latter being demolished in 1960 to make way for the new Police Headquarters. The view of the gardens of Victoria Square will still be familiar to people today, many of whom will have fond memories of enjoying their lunch hour there on hot sunny days.

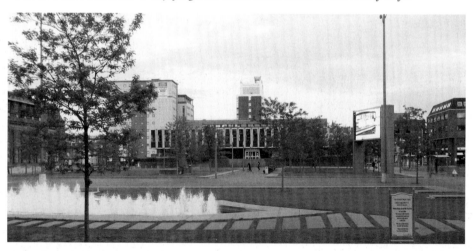

This same view only fifty years later illustrates the extent of the post-1960 redevelopment of central Middlesbrough, which has swept away many of historic Victorian buildings. Only the Carnegie Library stands unchanged in this view; others, including Hugh Bell School (which opened on 2 May 1892), no longer stand. The school was named in honour of a local industrialist and many thousands of children were educated here. The former pupils society existed for many years, an indication of the affection felt for the school. Teesside Law Courts, built on the site of the school, can be seen in the distance. Middlesbrough Police Headquarters, which replaced the United Methodist Chapel, has in recent years also been demolished, less than fifty years after it was built. Such is the progress of history.

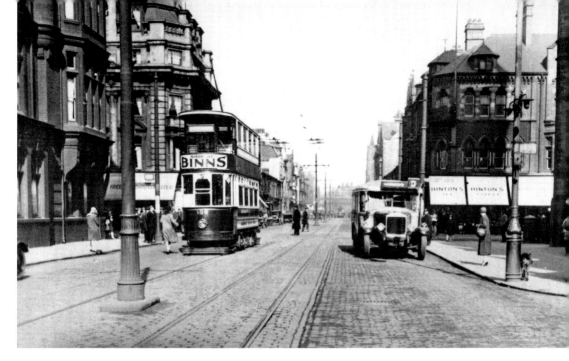

Taken close to the intersection of Corporation Road and Albert Road in the early 1930s, the layout of buildings in this image remained virtually unchanged up until the 1970s. A tram and a motor omnibus pass each other close to the Town Hall and the Corporation Hotel, whilst, in the distance, a single-deck tram can be seen close to Albert Road Railway Bridge, en route from the Ferry Road to Linthorpe village. The flagship Hinton's store, on the corner of Albert Road and Corporation Road, had been there since the 1890s. With its upstairs café, it was an extremely popular meeting place. Amos Hinton died in 1919, but his name lived on through the shops until the latter years of the twentieth century, when the business was sold.

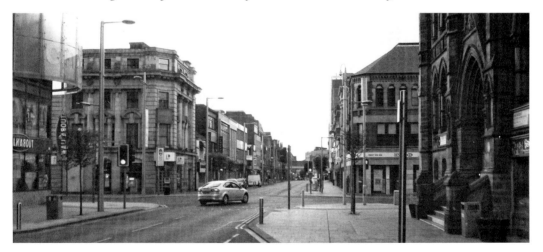

Eighty years later, Albert Road is still a main thoroughfare. At first, the view doesn't look too dissimilar, with the Town Hall and the Freeman Hardy & Willis building still standing (now Darlington Building Society). But the tramlines, like Hinton's store, are a distant memory. A fire destroyed the original building in the late twentieth century, and now a plaque commemorates the past on the new building standing there. Albert Road is still part of a bus route, but Albert Road Bridge, carrying the A66 trans-pennine route, overshadows the old railway bridge, which now carries a much reduced rail service.

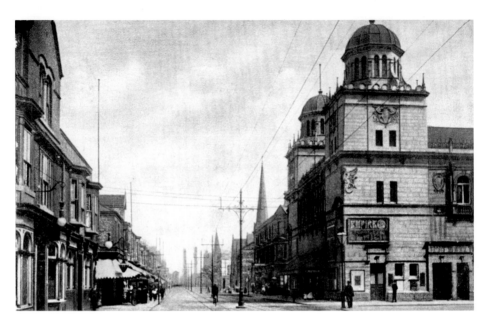

The Empire Palace of Varieties, shown here around 1908, has a distinctive history stretching back to the days of Music Hall. Built on a site previously used for circus shows, the Empire had six private boxes and other seating for more than 1,000 people. The Empire stood on the corner of Dunning Street, opposite Richardson Street, which is just visible here. In the distance are the tall chimneys of the nearby iron and steel works which encouraged much economic development in the town.

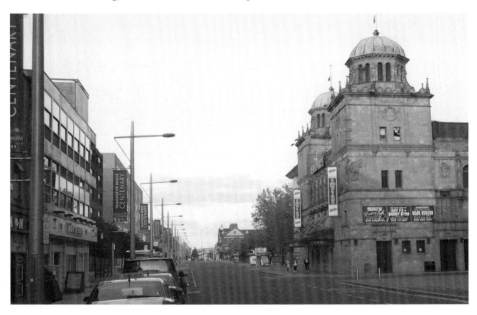

Whilst the Empire Palace of Varieties and the Town Hall both occupy their original sites in 2011, almost every other nearby Victorian building has been demolished. Old shops have closed, buildings have gone, new businesses have arrived and the nearby streets of terraced houses, once heavily populated, are no more. Note too, the disappearance of the tramlines and the tram poles that were once a familiar sight here. The Empire, however, is still a centre for popular entertainment. Taxis are parked, waiting for fares outside The Central pub.

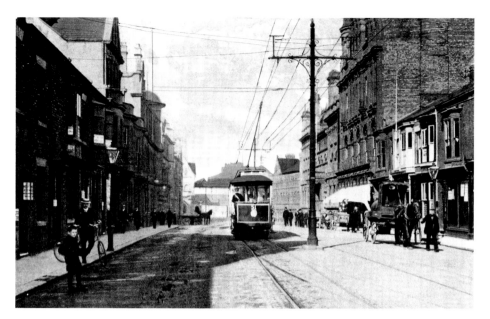

Having terminated at the Albert Railway Bridge, the No. 51 tram travels back down Albert Road (*c.* 1907), passing Newhouse's drapery store, where the white awnings provide shade for the front of the shop. The trams were a popular mode of transport, providing links to the town centre from newer suburban housing areas, like Linthorpe. This tram is travelling on one of the main routes, from Linthorpe village to the terminus at Ferry Road, in the old town. Note, it is single-decker, enabling it to pass under the Albert Railway Bridge.

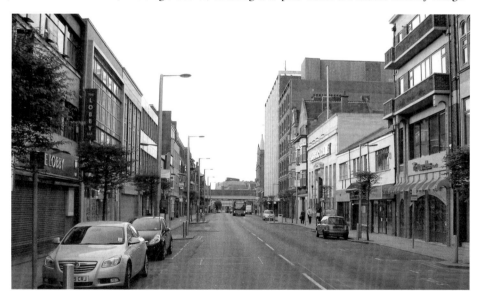

The tram's modern counterpart, an Arriva single-deck bus, travels down Albert Road en route for the Town Hall. The financial and service businesses, that occupied this stretch of Albert Road for many years, have now either closed or relocated; as a result, many buildings have undergone a change of use. Several have been redeveloped or, as in the case of the Middlesbrough Exchange, demolished to make way for the A66. Whilst the frontage of many buildings is very different at ground level, a glance above reveals traces of the buildings as they once were. One structure that has remained unchanged is the Albert Railway Bridge, just visible beyond the A66 road bridge.

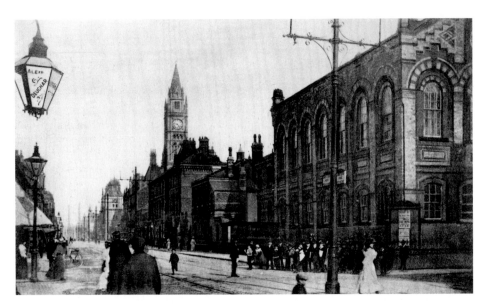

A group of schoolchildren wait patiently to cross the busy Corporation Road in this early-morning view. Nearby, a small boy has decided to take his chance and dash across. Behind them all is 'Big Wesley' (as the Wesleyan Chapel was affectionately known), on the corner of Linthorpe Road. Beyond the chapel, the Athenaeum Building and the Corporation Hotel are visible, along with the Town Hall, where the clock, a timepiece over the years for many citizens of Middlesbrough, has just reached 9.25 a.m.

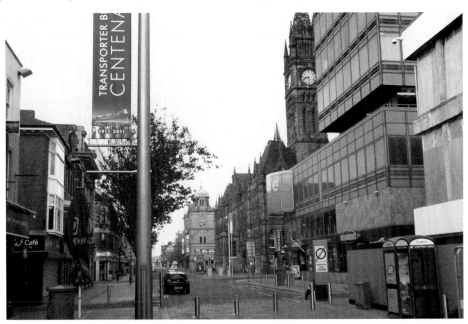

Today, this section of Corporation Road is part of the pedestrianised shopping area around the Cleveland Centre (The Mall), one of the two main shopping units in Middlesbrough. The Empire Theatre and the Town Hall stand seemingly unchanged, but Big Wesley, the Athenaeum Building and the Corporation Hotel have all gone. The corner of the 'CNE' building, a huge glass structure that dwarfs the Town Hall, is just visible. Development of the town centre continues, as is evident from the wooden boarding surrounding the rebuilding on the right.

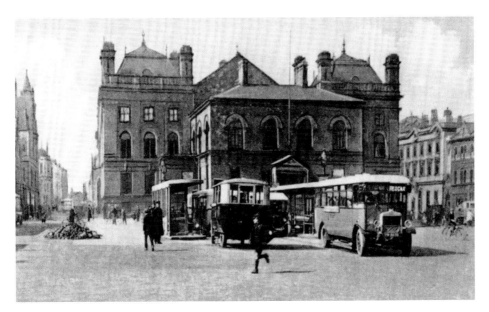

The Middlesbrough Exchange Company Ltd (formed in 1864) was the driving force behind the building of the iconic Exchange Building on Albert Road, which opened on 28 July 1868. Construction cost £28,000, despite a 130ft tower being omitted due to a lack of money, and the building became an icon of local industrial heritage. Beyond the Exchange was Exchange Place, seen here with Wilson Street on the left and Marton Road opposite. The Exchange Bus Station first opened in 1925, and in this scene from 1927 several buses stand awaiting passengers. A major bus terminus was constructed here by Middlesbrough Tramways Committee in 1930–31, to service the increasing number of out-of-town housing estates.

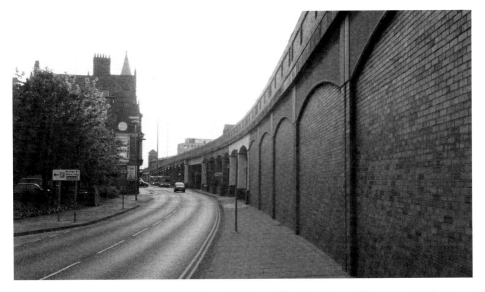

The routing of the A66 trans-pennine road through the middle of Exchange Place completely changed the area, dividing Exchange Place in half. Today, all that is visible from Wilson Street is one of the supporting walls of the road bridge as it crosses Albert Road. The decision to construct this route was highly controversial. The demolition of the Exchange Building was considered by many to be an act of negligent destruction; an important part of the town's history lost forever.

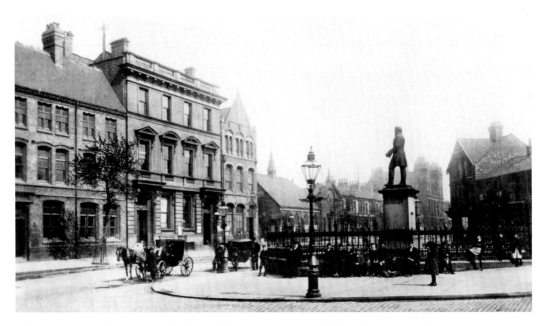

Although many will remember Exchange Place as a busy bus station, it was originally a very picturesque, elegant area, as seen here in 1908. The unveiling of the statue of ironmaster Henry Bolckow, on 6 October 1881, by Lord Cavendish, took place during the town's 50th Jubilee celebrations. Lord Cavendish, along with John Vaughan, played an important role in the history of Middlesbrough. Enclosed by an octagonal fence, the statue was the centrepiece of the Place. Also in view is the Freemason's Hall, which opened on 12 January 1861. The site for the hall cost £159, while the building and furniture cost £838.

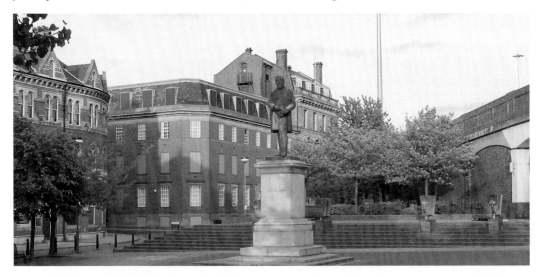

One of the more pleasing trends in the redevelopment of Middlesbrough is the cleaning and restoration of some original buildings, particularly evident in the work completed on Exchange Place. Despite its proximity to the A66 (the supporting wall of the road is just visible), Exchange Square (as it is now renamed) is an elegant tree-lined area, once again under the scrutiny of Henry Bolckow, whose statue stands in its midst. Teesside Archives now occupy the distant building in the Square. Many visitors must surely note the contrast between the noise and bustle of the former bus terminus and the relative peace and serenity found there today.

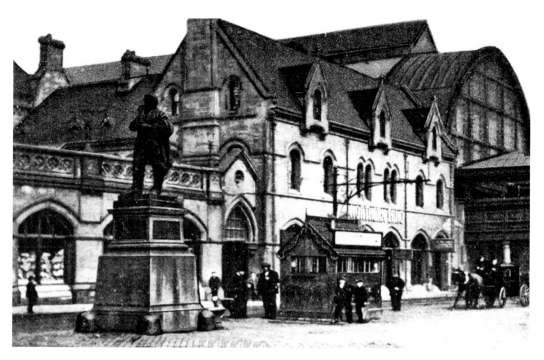

The western end of Exchange Place approaches Albert Road and Middlesbrough Railway Station. The statue of John Vaughan was unveiled here by Sir J.W. Pease on 29 September 1884; a fitting tribute to a leading figure in Middlesbrough's industrial history. The statue was later moved to Victoria Square, on 23 October 1914. Behind the Hansom cabs driving along the cobbles under the Albert Road railway bridge, there is a glimpse of the ornate glass roof that once covered the railway station. The *Northern Echo* sign adorns the adjacent building and Winterschladens, the wine merchants, occupied the premises behind the Vaughan statue.

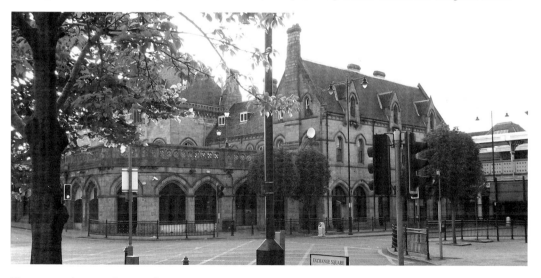

There is a striking similarity to the previous image in this contemporary view of the scene. The buildings opposite Exchange Place (or Square, as shown on the street name plate), not only still exist but also have been cleaned up and restored. The most obvious change is the loss of the glass roof over the railway station, due to damage during bombing raids of the Second World War. The tree in the foreground lends an air of elegance to the scene.

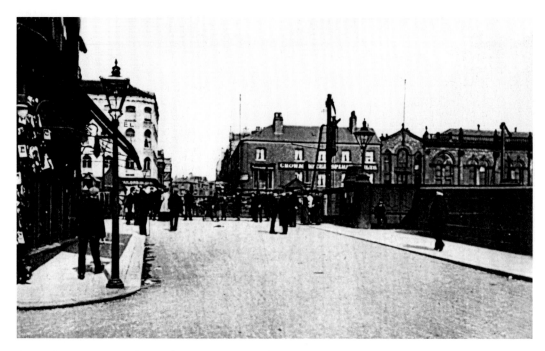

Sussex Street was once the southern perimeter of the town, petering out into a lane to Linthorpe. When a new branch line opened to Middlesbrough Dock, a small halt and platform were built in 1841, close to where the lane crossed the railway. The railway crossing was built later, when the railway opened to Redcar in 1846. Seen here in 1908, this view from the corner of Station Street looks across to the Crown and Sussex Hotels in Bridge Street West.

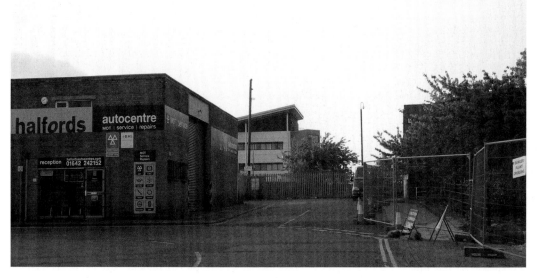

The scene today is totally different; although the railway is still operating, there are no surviving buildings on either side of the line, apart from the nearby railway station itself, which is here, slightly off-picture to the right. The level crossing has gone too, whilst Halfords has replaced the shops that once stood on the corner of Station Street. This image is another example of the extensive changes that have occurred in this part of the town.

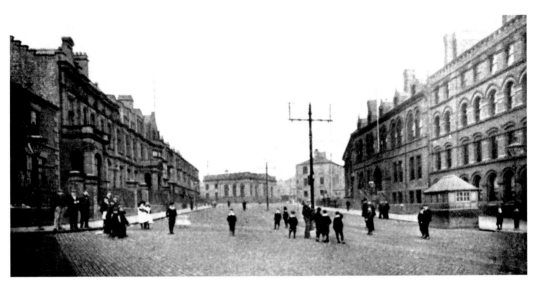

The town quickly expanded southwards as the Owners of the Middlesbrough Estate (OME) sold off various lots of their land. Developers laid down new streets, including the architecturally pleasing area around Queens Square, shown here around 1903. Wealthy individuals lived here at the Cleveland Buildings, including Henry Bolckow (1841–54) and John Vaughan (1841–58). To the rear were well-laid-out gardens looking onto the nearby hills. Opposite, a large, elegant, two-storey redbrick house was owned by local shipbuilder John Gilbert Holmes, whose sloping lawns reached almost as far as Albert Bridge. Bought by the National Provincial Bank in 1864 as business premises, it was demolished in 1872, when the current building was erected. On the left is Queens Terrace, a stylish row of eight houses built in 1850. Today they are also commercial premises.

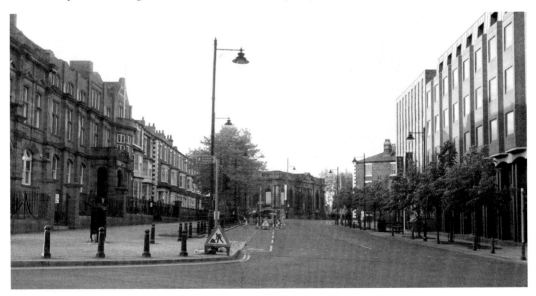

It is good to see that many of the Grade II listed buildings in Queens Square remain. Apart from the modern structure in the right foreground, most of the original buildings are easily recognised today, including the mid-nineteenth century houses once occupied by Bolckow and Vaughan. A blue plaque on the front exterior of the property marks their occupation of the houses. Despite the old cobbles in Queens Square being replaced by tarmac, much of the elegance of the area still remains.

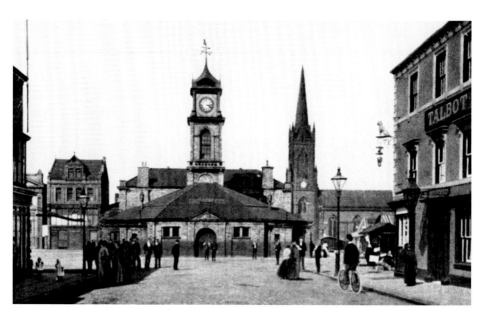

In 1841, the OME formally handed development of the town over to twelve Improvement Commissioners. In 1846, they erected a Town Hall in the centre of the Market Place. Made of stone and white brick, the building contained a communal hall with a gallery, a lock-up (with two cells) and a house for the Superintendent of Police. An octagonal market was built around the base of the prominent clock tower. In 1862, W.E. Gladstone was received at the Town Hall for a banquet to celebrate his visit. Taken from South Street, this view shows the Old Town Hall and the Talbot Hotel (also known as 'Sackers' or 'The Dog'), familiar landmarks in Victorian Middlesbrough.

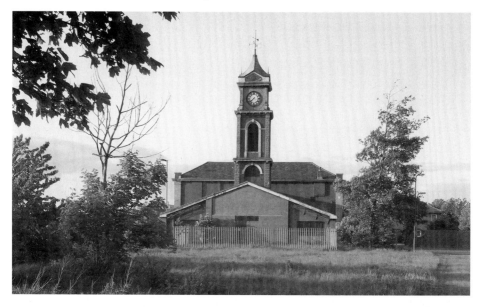

Today the area is overgrown with grass – if it weren't for the Old Town Hall building it would be almost impossible to locate this scene. It is very sad that the Old Town Hall, a historic Grade II listed building, stands empty and in some state of decay. In recent years, it was used as a community centre; now large swathes of grass cover much of the site of the surrounding old town, an ironic reminder that this was open farmland until two centuries ago.

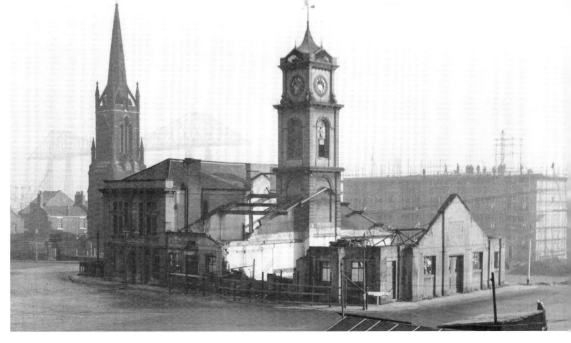

St Hilda's, as the old town came to be known, has undergone several periods of change during the 180 years since it was first laid out. The first major changes occurred as part of the inter-war slum clearance, a programme which gathered pace in the post-1945 years. As seen here around 1959, new flats replaced the demolished slum properties in the old town. The Old Town Hall was also renovated and builders' huts can be seen occupying the Market Square – up until then the venue of the much missed Middlesbrough Market. In the background, the Transporter Bridge and St Hilda's Church, iconic buildings in the opinion of many Middlesbrough citizens, dominate the skyline.

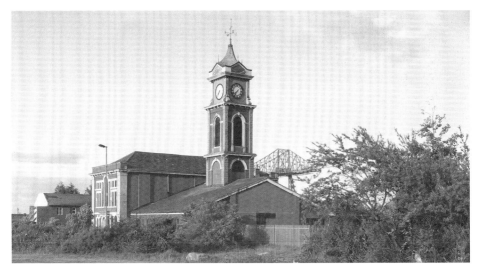

The Transporter Bridge celebrates its centenary in 2011 but, alas, St Hilda's Church was demolished in 1969, a victim of the 1960s rebuilding programme. The basic structure around the Old Town Hall is familiar, but close inspection reveals a sad tale of exterior decay, with the interior, being open to the weather, sadly in a similar state. The original Middlesbrough Farm buildings stood close to this elevated site. It is easy to imagine the scene 200 years ago, when the Parrington family, who lived at the farm, would have watched through the windows of their farmhouse sailing ships as they navigated the River Tees on their way up to Stockton.

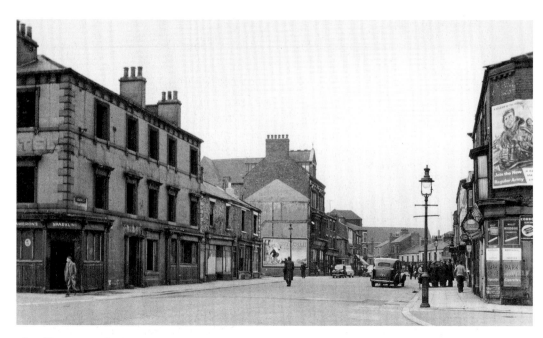

The old town was built using a grid system of streets radiating out from the Market Square. One of them, South Street, which ran down to Sussex Street, is seen in this late 1950s view; a time when the area was in a state of some decay. In the foreground, the Talbot Hotel awaits demolition; the other buildings around it were soon to follow. It is interesting to note the roof of St Mary's Cathedral in the distance.

Today, the hustle and bustle of this once busy urban scene is but a memory, and although the remains of the road are visible, the area is covered with grass. Attempts at the redevelopment of St Hilda's have met with mixed results. After the clearances of the late 1950s, many new properties were built, but sadly, by the 1980s, these properties had become slums and many were demolished. Another rebuilding programme followed, which it was hoped would bring people into the area. This wasn't a success, however, and in recent years these too were demolished. Following an announcement from the Mayor in July 2004, St Hilda's was identified as an area for intervention within Middlesbrough. Recently, phase three of the Greater Middlehaven Strategic Framework plan has included the erection of several new buildings, including the relocated Police Headquarters. It is to be hoped that more rebuilding will follow.

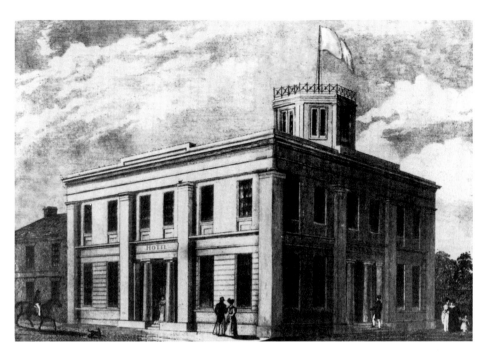

The Middlesbrough Exchange Association was formed on 9 September 1835. Inspired by the town's growing commercial success, it built a Coal Exchange, with offices, public rooms and a residential hotel. This two-storey building, on the corner of Commercial Street and North Street, was constructed in Greek-revival style. It opened in 1837 and was named the Exchange Hotel (seen here in a contemporary drawing). On 29 October 1838, the first royal visit to the town took place. The Duke of Sussex, uncle of Queen Victoria, was entertained here amidst great scenes of celebration. When the hotel was later found to be unprofitable, it was sold, in 1853, for £2,750, to the newly formed Middlesbrough Council. It was renamed Corporation Hall, replacing the Old Town Hall building, which had become too small.

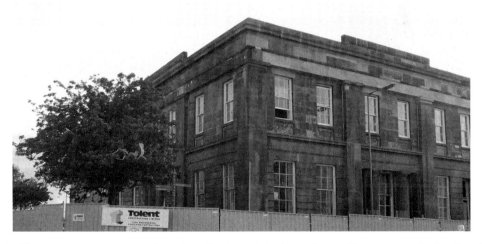

The building is now being converted to a 'MyPlace' youth facility, a £4.2 million revamp which will include a café, chill-out space, crèche, climbing wall, media studio, interactive library, music facilities, gym, bowling alley and sensory room. Standing, as it does, in the midst of a dilapidated area, this change of use is to be applauded, and it may be the catalyst for further redevelopment of the surrounding area.

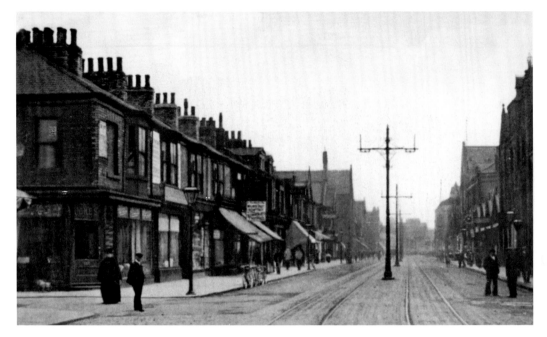

Newport Road (*c.* 1910), looking towards Linthorpe Road from the corner of Dale Street. The old Cleveland Hall, on the right, opened in 1872 as an auction and display rooms; it soon became a social club and then, after being rented by Thomas Thompson, it became Middlesbrough's first cinema in 1908. Closing in April 1930, the hall was demolished in 1936 to make way for the new United Bus Station. The tall building opposite opened as a Presbyterian church in 1865 and became the Scala Cinema from 1919 to 1961.

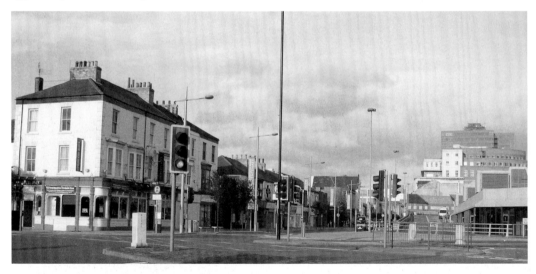

Today, the frontage of the buildings in the immediate foreground, beyond the Princess Alice public house, survive, along with some of the buildings further away. However, once again there has been a major redevelopment of the area and the land around it. On the mid-left, one of the entrances to the Hill Street shopping centre can be seen; many streets of terraced houses were demolished during the construction of this centre. With a similar development opposite, when the bus terminus was rebuilt many other properties were demolished, giving this area a very different visual profile today.

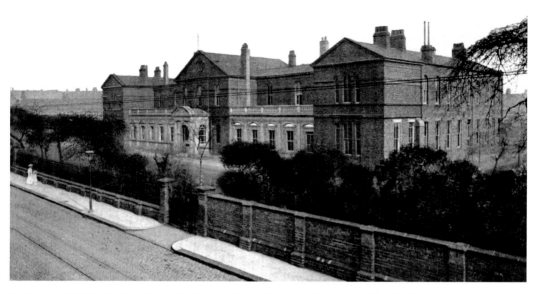

In the early 1860s, the Hustler family donated 'Long Plantation', an acre of land adjacent to Newport Road, along with a financial contribution to the £7,865 construction costs, for the building of Middlesbrough Infirmary. The new hospital, opened by Henry Bolckow on 5 June 1864, replaced the town's Cottage Hospital, which had opened in 1859. Many of its patients were casualties from the nearby Ironmasters District and the hospital soon won the respect and high regard of the citizens of the town.

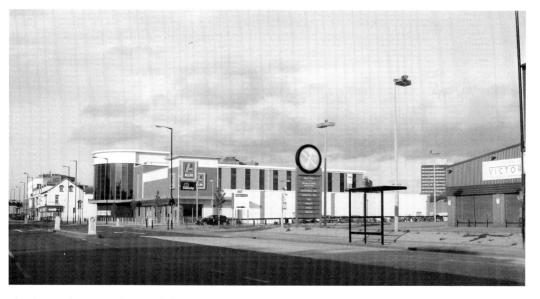

The hospital remained one of the most familiar sites in Middlesbrough until its recent closure and subsequent demolition in 2008, an act which caused great anger among thousands of Middlesbrough citizens. A petition of over 7,000 signatures, and a great deal of local media attention, failed to save the building from its eventual fate. Today the site is a Travel Lodge and Aldi supermarket. Middlesbrough Infirmary may have gone, but it is certainly not forgotten.

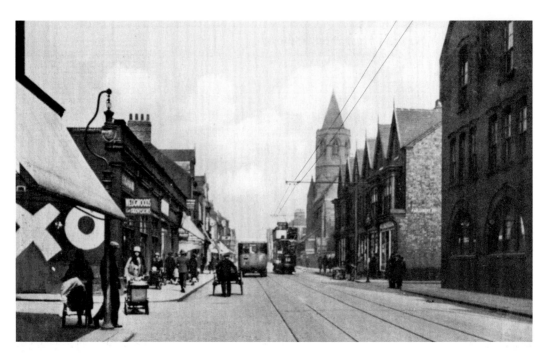

For many years the only road between Middlesbrough and Stockton was the circuitous route through Linthorpe and Acklam. In 1858, a turnpike was opened across marshland and the old River Tees to Newport village. It went no further until Newport Road was built to Boundary Road across North Acklam, on farmland owned by the Hustlers. One of the main routes into the town, Newport Road was a busy retail centre with a variety of shops and products. One shop, Wedgwood's Provisions, which stood on the corner of Unthank Street, can be seen here in around 1910. The spire of St Paul's Church is visible as a tram travels towards the entrance to Parliament Street in the foreground. St Paul's Church was consecrated in 1871 after a substantial donation was made towards its construction by the Hustler family.

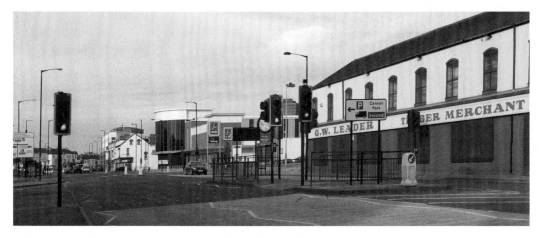

Today, Newport Road is a shadow of its former self; virtually no original buildings survive along Newport Road itself, although there are some in the immediate area to the east around Parliament Road and Union Street. St Paul's Church survived bombing raids during the Second World War, but became increasingly fragile during the 1960s and so was demolished in 1967. One little bit of history to survive in the area is the old Pavilion Theatre, where the name is still visible on the front of the building.

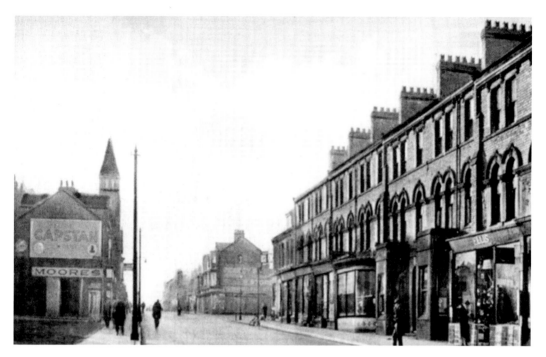

A view from Orwell Street, looking to Newport Hill and the junction of Newport Road and Samuelson Street. A large advert for Capstan Cigarettes adorns the wall above Moores Provisions Store on the left, whilst Ellis' Newsagents is on the right. In the distance is the spire of St Cuthbert's Church, which stood on Heywood Street. Many retail businesses were established along Newport Road (at this time a main route to Stockton), so this was usually a busy part of town.

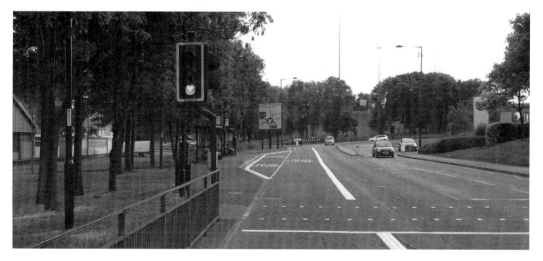

The trees that line this section of Newport Road today hide the spire of the former St Cuthbert's Church completely. The premises is now the Phoenix Squash and Leisure Centre. There is no residential housing along this section of Newport Road now; it is sad to see that it has become lined with warehouses and other industrial premises. Many former residents look back fondly at the time when they lived in Newport Road, or one of the many streets close by, commenting that the sense of community spirit back then is often lacking in the new suburban housing estates where they were relocated.

2

'MAM WENT EVERY SATURDAY'

Many people's memories of Middlesbrough are of shopping in the town centre; do the familiar street and shop names still survive today…?

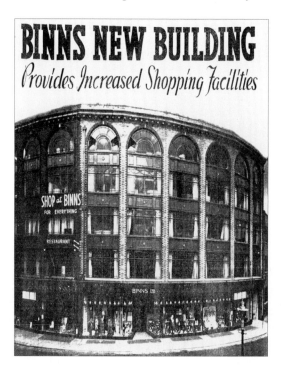

Binns quickly became one of Middlesbrough's flagship stores, after it opened in 1923 on the site of Manfield's Boots Store. This success led to an extension in 1937, but, unfortunately, the store burnt down in a spectacular blaze on 27 March 1942. It was subsequently rebuilt, and is shown here at the time of its reopening.

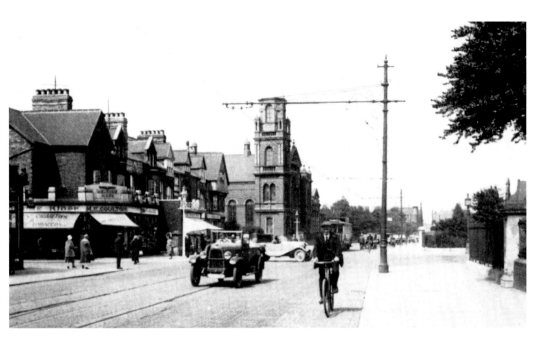

This 1930s view shows the Park Wesleyan Chapel on the corner of Ayresome Street and a busy Linthorpe Road. In the foreground, Coulton's Kiosk, at the entrance to Kensington Road, is part of a charming Victorian terrace of six houses – part of the development southwards along Linthorpe Road. A regular tram service went down Linthorpe Road, from Linthorpe village to the Transporter Bridge. I can't identify the two open-top cars; are they an Austin Seven and a Bullnose Morris? The perimeter fence on the right marks the edge of the gardens in front of Dorman Museum, and the distant trees surround the old cemetery.

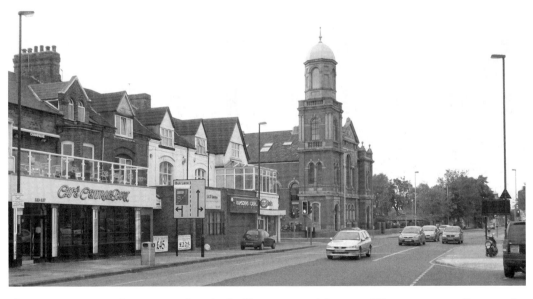

The scene is very similar in 2011, but the buildings are used for very different purposes. Two popular restaurants, Café Central Park and Fellini's, are located in the terrace of Victorian houses. Although the exterior of the building looks very similar, Park Wesleyan Chapel has, remarkably, been converted to private residential properties. The old cemetery is still lined by trees but it has now been converted to open parkland.

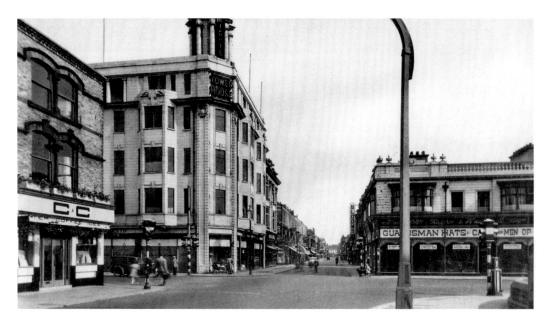

This view (*c*. 1961) is Linthorpe Road at the intersection with Grange Road. The presence of traffic lights shows that this was the era before pedestrianisation. Traffic was often very heavy along these routes and many shoppers will recall a busy shopping day in Linthorpe Road, trying to avoid the traffic as they walked along! Wright's Tower House, which opened in 1910, was for many years a very popular shop. It stood on the corner of Grange Road and Linthorpe Road. Far away in the distance the Crown Hotel can be seen on the northern side of the railway.

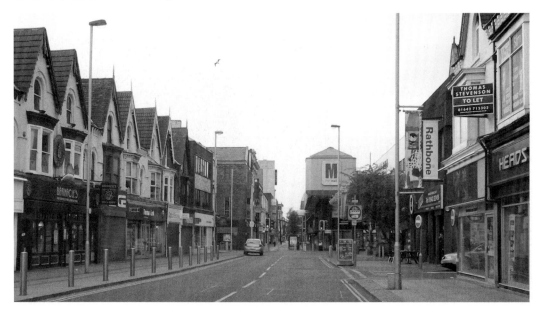

The 2011 view is taken to the south of the previous image; although Linthorpe Road is still part of the 'shopping area' in the town, there have been several wholesale changes. The buildings on the right were replaced by the Cleveland Centre in the early 1970s; Wright's Tower House was demolished in 1986, becoming a McDonald's restaurant, and this part of Linthorpe Road is now pedestrianised.

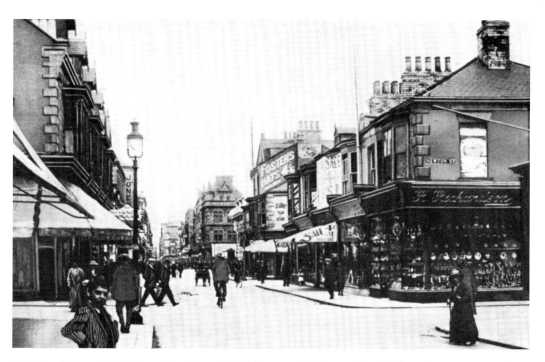

As it headed north, Linthorpe Road was joined by several other roads, which no longer exist, such as Newton Street, seen here around 1910 behind the lady crossing the road. Richardson's the jewellers are on the corner of Newton Street, whilst Foster's hats, available at 4s 6d, are advertised on the end of the building in Fallow Street. The boy in the foreground stands close to the corner of Gilkes Street and the premises of Francis Wilson the bootmaker. Today, this is the premises of Curry's electrical stores.

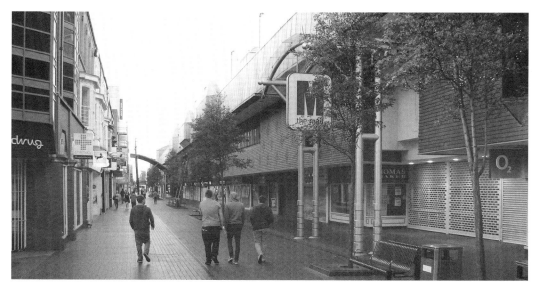

This section of Linthorpe Road is today dominated by the Cleveland Centre, a development that has been at the heart of the retail trade in Middlesbrough since it first opened in the early 1970s. Construction involved the large-scale demolition of many streets in the area, with street names like Wesley Street, Fallows Street, Newton Street, Bottomley Street, Norton Street and Fletcher Street surviving only in the memory of former residents.

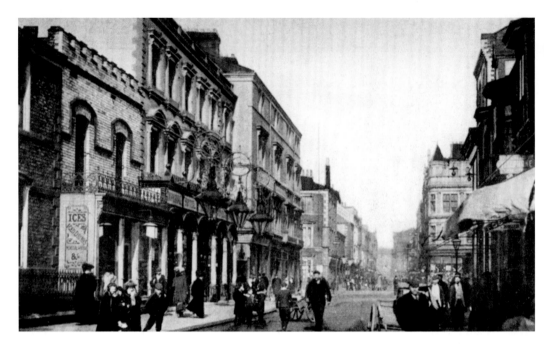

Moving further north along Linthorpe Road, this image (*c.* 1910) shows the three large, ornate lanterns over the frontage of the Imperial Hotel on the left, with the corner of Wesley Street opposite. Beyond the Imperial Hotel are the premises of Manfield's Boot Store and the King's Head on Corporation Road, with the rest of a busy Linthorpe Road visible beyond them.

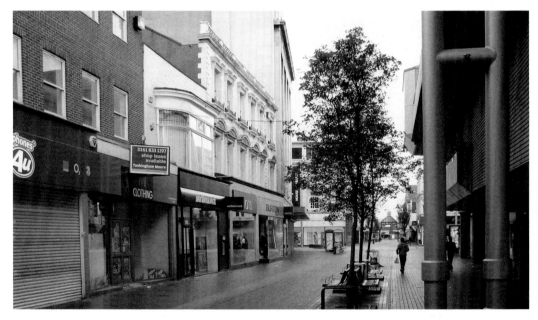

There has been a lot of change in this area of Linthorpe Road. However, above ground level, clues remain about the past; examine the building occupied by the shops Evans and Burton and you will see that the upper storeys are almost identical to those in the image from 1910. However, the Imperial Hotel, although still trading as late as the 1960s, has disappeared with no signs of its existence left today.

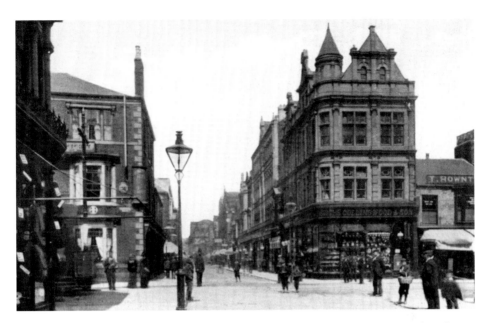

Here the King's Head Hotel (c. 1908), which stood at No. 1 Newport Road on the corner of Linthorpe Road, can be seen. The King's Head opened in 1862, when the first section of Newport Road was constructed. It was a popular drinking venue before it closed, when John Newhouse bought the site for his new store in 1912. A careful examination of the scene will reveal a tram passing the hotel as it travels down Corporation Road towards Newport. Opposite is a well-designed and elegant building, occupied by Collingwood's the jewellers – like Newhouse a long-established retail name in the town.

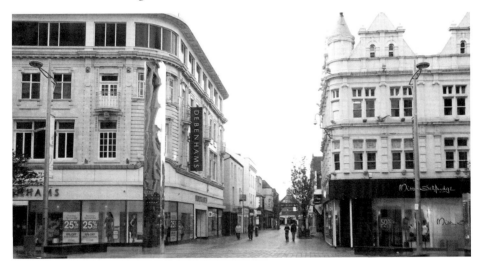

Remarkably, the neo-Jacobean style of Collingwood's building has survived seemingly intact, complete with its classical features, including the curved corner, round turret and Dutch gables. The building's east elevation has been extended in a style identical to the original architecture. No longer a jewellery shop, it is now Miss Selfridges, one of several fashion shops trading from here in recent years. Newhouse's has also changed ownership, having sold out to Debenhams in 1973. The exterior building occupied by Newhouse's has changed little structurally, apart from the addition of a new top floor. Note also the pedestrianisation of Linthorpe Road and Corporation Road.

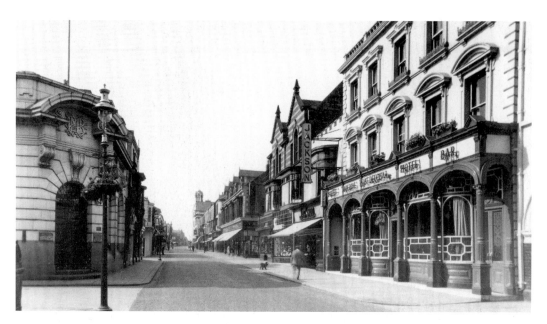

Linthorpe Road in the early 1960s; obviously taken at a very quiet time, as this was usually a very busy route. Soon this area would be pedestrianised, as the buildings on the left were swept away by the Cleveland Centre. In the distance is Wright's Tower House, whilst the buildings in the foreground include the Imperial Hotel *(right)* and the National Provincial Bank on the corner of Wesley Street on the left. Next to the Imperial is Jackson's the tailor, on the corner of Newport Crescent, whilst further down is Gilkes Street. The image shows that the area, with its many shops, was still at the heart of the retail trade at this time.

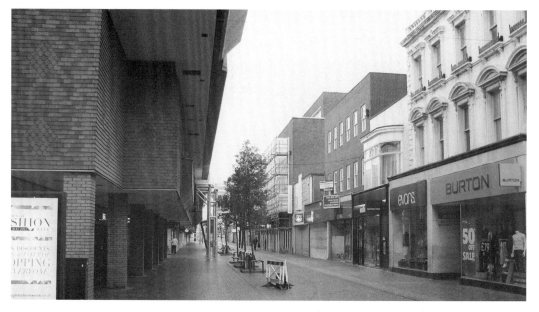

Many shops are still to be found in this section of Linthorpe Road, most being modern developments. Once again, the Cleveland Centre is visible on the left of the image, but note the relatively unchanged upper floor of the building, which was once the Imperial Hotel and Jackson's the tailor shop, where the bow window survives unchanged. The pedestrianisation of Linthorpe Road is evident once again.

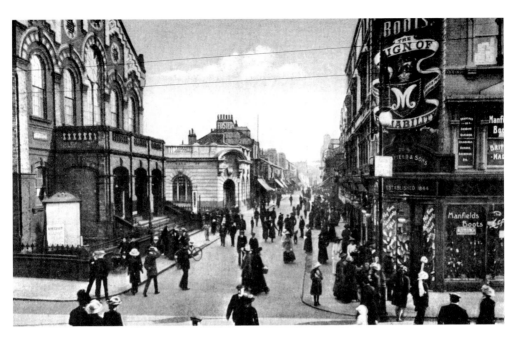

This scene looks south down Linthorpe Road from the busy intersection with Newport Road. On the immediate right is Manfield's Boot Store, which stood until 1923 on the site occupied today by Binns. Opposite is the Wesleyan Chapel, which cost £6,000 to build and could seat up to 840 worshippers. When the chapel opened on 20 September 1863, this site was the southern edge of the town. A school was housed on nearby Wesley Street until 1908, when a large hall, which became very popular for lectures and concerts, replaced it. The white stone building of the National Provincial Bank premises are visible on the corner of Wesley Street.

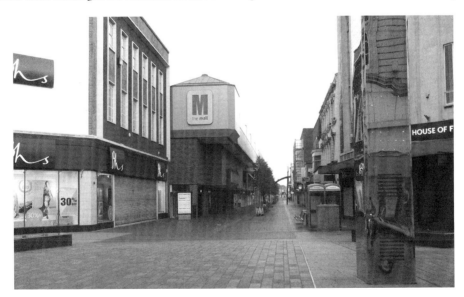

A very different scene exists today with Bhs, the department store, standing on the former site of the Wesleyan Chapel – the latter was closed and demolished in 1954. The huge 'M' on the wall of the Cleveland Centre is very visible. It is a very different scene from the previous view; a comparison of the two views reveals the massive changes the area has undergone.

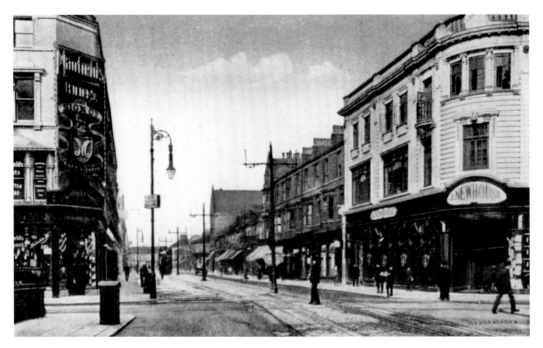

This is John Newhouse's department store in 1923. The building replaced the King's Head Hotel when the store relocated from Albert Road in 1912. On the left is Manfield's Boots Store, which was to close in that year. Beyond Newhouse's is the United Presbyterian Church on the corner of Hill Street. Built in 1865, the final service in the church was held on 27 July 1919. It then became the Scala Cinema, eventually closing on 8 April 1961. A distant tram travels down Newport Road on its way to Norton Green.

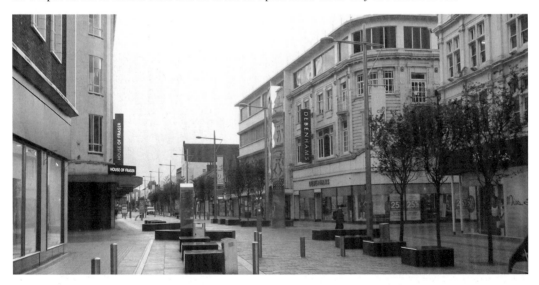

Today, this pedestrianised junction still lies at the heart of the town's main shopping area and is still quite recognisable from the image of nearly ninety years ago. The old Newhouse store is now Debenhams, but with its curved corner and second-floor balcony, it has a very similar exterior; the one major change is the addition of an extra floor. Part of the sidewall and the gable-end of the former Scala Cinema building are also visible in the distance. The addition of the trees and the marble seats add to the attractiveness of this area.

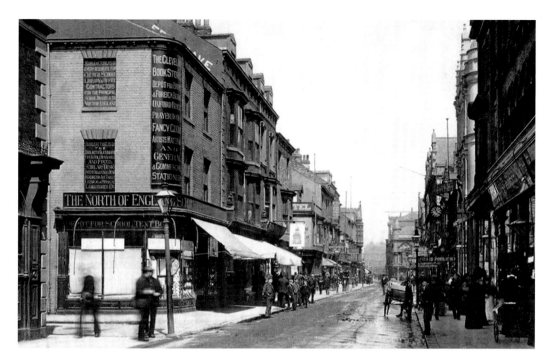

This high-quality view shows the northern part of Linthorpe Road. As well as the Leeds Hotel, visible in the distance, the Masham Hotel, a mid-nineteenth century Grade II listed building, can also be seen on the left, at No. 49 Linthorpe Road. In the foreground, to the left, is the Cleveland Book Store, which was on the junction with Johnson Street. In the distance lies the old town, just visible across the railway.

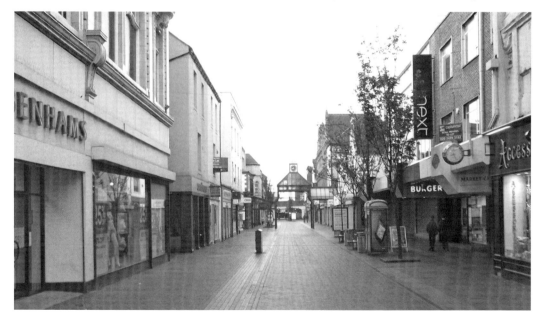

The area is still part of the main shopping area in Middlesbrough. The old Masham Hotel building, which is now a retail outlet (the Masham Hotel closed in the 1990s), marks the entrance to the Hill Street Shopping Centre. Linthorpe Road is still very much at the heart of the main shopping area in the town.

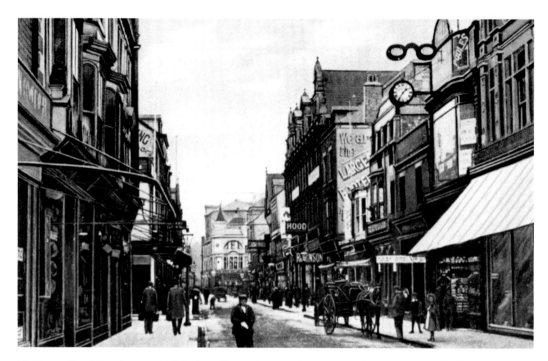

Linthorpe Road has been established as the main shopping area in the town since the late nineteenth century. This image (*c.* 1908) was taken just north of the intersection with Corporation Road, a point close to the Next clothing outlet currently. One hundred years ago, in an era before the national high-street names became established, many shops were still owned by local retailers. At No. 14 Linthorpe Road, in the distance on the right, is the Leeds Hotel, a popular venue until it was bombed during the Second World War.

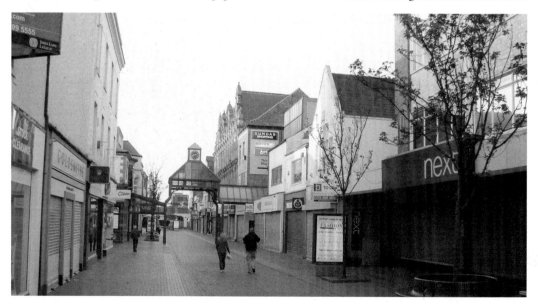

Changes of retailer have often resulted in an alteration of frontage design in many retail outlets. However, this view of Linthorpe Road, taken when most premises are closed, allows us to see that in many buildings the upper storeys remain unchanged. It is often here that historians can find evidence of the past.

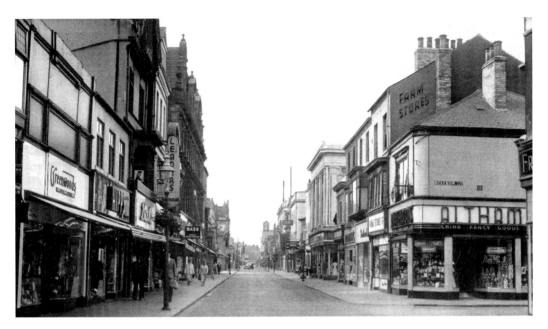

This view, from around 1963, looks south down Linthorpe Road from the corner of Bolckow Street. This was a time when many of the Victorian features of the buildings in this area were still present. On the right are the white stone columns that adorned the Marks and Spencer's store at that time, and the elegant arched clock, familiar to several generations of shoppers in the twentieth century, is visible opposite. In the distance, a car can be seen turning from Linthorpe Road into Corporation Road.

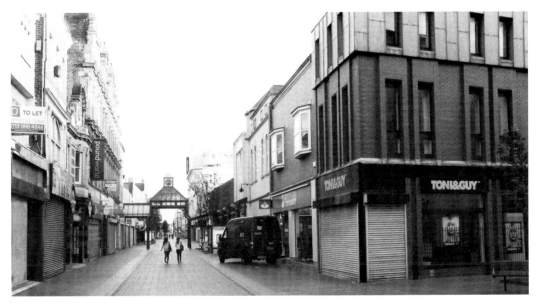

Bolckow Street today is a truncated version of the original road, as most of the area was demolished to make way for the building of the Hill Street Shopping Centre in the late 1970s. Marks and Spencer's store is still there, however, and is now incorporated into the Hill Street Centre. The steel arch is a more recent addition to the profile of Linthorpe Road; an attempt to recreate a traditional feel to the shopping experience in town. Many people will remember walking along here on a Saturday, desperately trying to avoid the passing traffic.

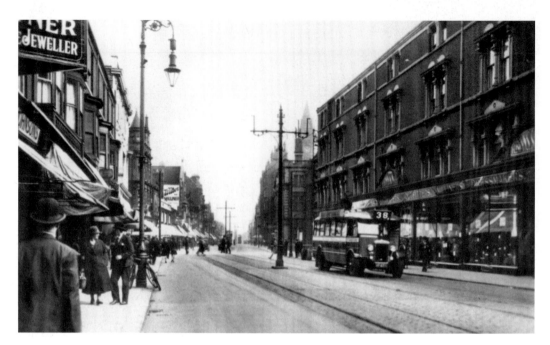

A view of Corporation Road, close to where it crosses Linthorpe Road, looks east towards the Town Hall and the distant junction with Marton Road. Many familiar buildings crowd this busy scene, including 'Big Wesley', Collingwood's jewellery shop, Saltmers and Wilson's. On the right, behind the United No. 38 bus, is a rare view of the old Binns store, which burnt down in March 1942. It is also interesting to note that the tramlines are still in place and this, along with the distant tram, reveals that the image must be pre-June 1934, when the last tram service ran in Middlesbrough.

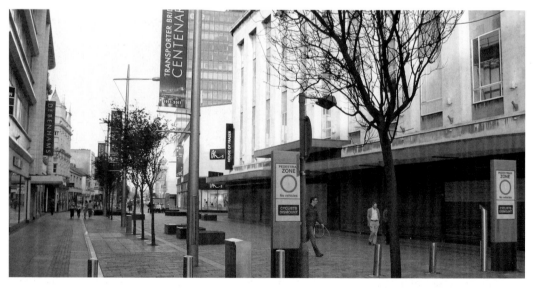

The contemporary view shows that the biggest change has been the pedestrianisation of the area – a relatively recent development to make the centre of town a more 'shopper-friendly' location. There is a lot to recognise in the scene with the 'new' Binns building on the right and Bhs on the site of the old Wesleyan Chapel.

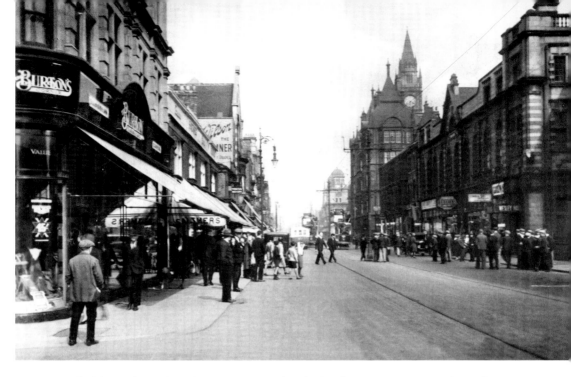

A wonderful period view from the early 1930s. Taken further down Corporation Road outside Burtons shop, which replaced Collingwood's the jewellers, it shows Saltmers and Wilsons on the left, with the buildings from the Wesley Chapel down to the Corporation Hotel on the right. As the hands on the Town Hall clock approach 4.30 p.m., two trams pass each other near the Empire Palace of Varieties, whilst a crowd of people have gathered close to the Wesley Hall name plate. Other people spill out on to the road, with seemingly little concern for any danger from passing traffic.

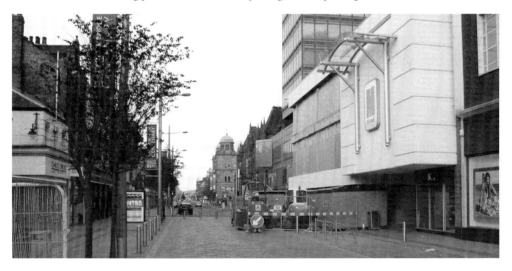

Despite a different perspective, the modern view shows, nevertheless, that there has been significant change in this area. The wall of the former Wilson's building, on the corner of Dundas Street, is visible and several properties in this row have unchanged exteriors, except for different retail usage. The Cleveland Centre on the right, however, has meant that all of the buildings visible here in the previous image have been demolished and replaced.

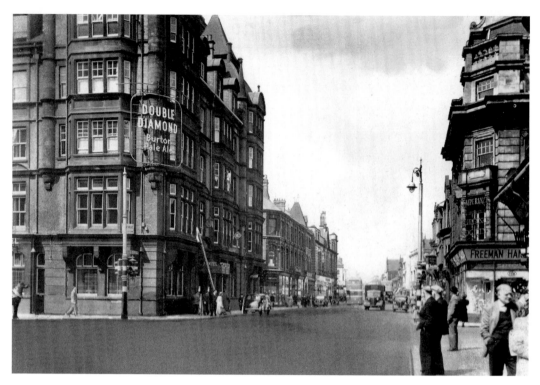

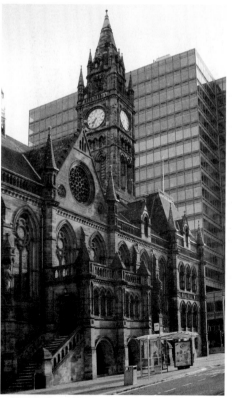

Above: The Corporation Hotel, on a site between the corner of Albert Road and Fletcher Street, is seen here around 1963, when it was one of the town's leading hotels. First licensed in 1863, this four-storey Edwardian building replaced earlier premises. The hotel, with its famous 'Double Diamond' sign, was a popular meeting place for many local people. The main door on Corporation Road opened to a small cocktail bar on the right and a large main lounge on the left. The actress the late Wendy Richard was born here in 1943, and many famous show-business stars, such as Charlie Chaplain, Morecambe & Wise and Houdini, stayed here whilst performing at the nearby Empire Palace of Varieties. The shoe shop Freeman Hardy & Willis can be seen on the right of the picture with Binns store in the distance.

Left: The demolition of the Corporation Hotel, in 1971, was a major blow to many local people, who regarded it as the loss of yet another part of the town's history. For many it seemed to be one of the more telling losses; the centre of town had changed beyond recognition by the first decade of the twenty-first century. The Corporation name lived on with the replacement high-rise glass building, being initially called Corporation House, although in more recent years it has become CNE (Centre North East). The Cleveland Centre lies beyond this building, with the pedestrianised areas close by.

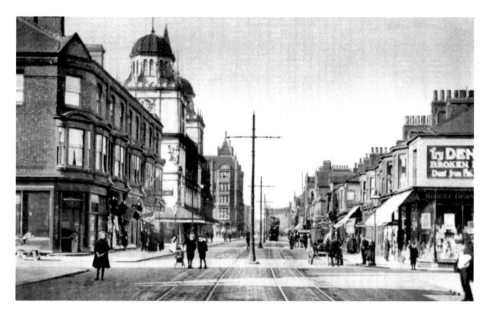

Looking from a point east of the Empire Palace of Varieties, this view of Corporation Road (*c.* 1908) shows Pine Street on the left, with Denis's shop on the corner of Buxton Street opposite. In the distance a tram is passing the Corporation Hotel. As always, the presence of the photographer attracts one or two children – notice the two boys in the middle of the road along with a pram and occupant. They could not know their place in posterity would be secure – a moment in time preserved forever.

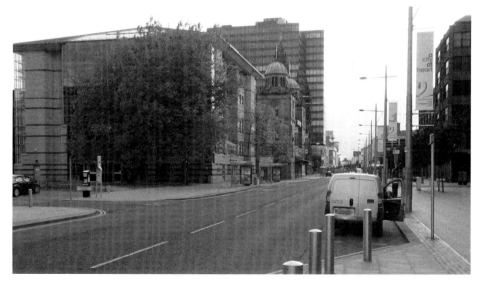

Today the Empire Theatre is overshadowed by the modern buildings around it. Most of the older streets and buildings have either changed considerably or disappeared altogether. An example is Elm Street, in the foreground on the left, which is now little more than a small car park; a hundred years ago this was lined with over forty terraced houses and a Presbyterian Church on the corner. On the other side of Corporation Road, similar wholesale changes have also taken place, with a swathe of terraced streets having been demolished. Buxton Street, Gurney Street and Fry Street are just some of the names that have disappeared, or have become name plates standing along empty roads.

3

WHEN MEN
WORKED HARD

Many people in Middlesbrough were employed in the heavy industries located along
the banks of the River Tees…

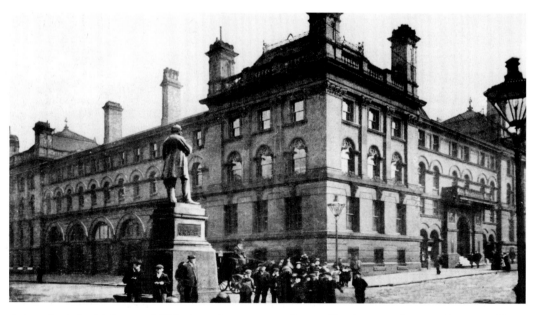

As a major industrial centre, Middlesbrough was very well-served by the magnificent Exchange Building,
seen here from Albert Place where the statue of ironmaster John Vaughan stood. The architectural glory
of the building can be fully appreciated from this location. It was a building held in high esteem by many in
the commercial world at that time.

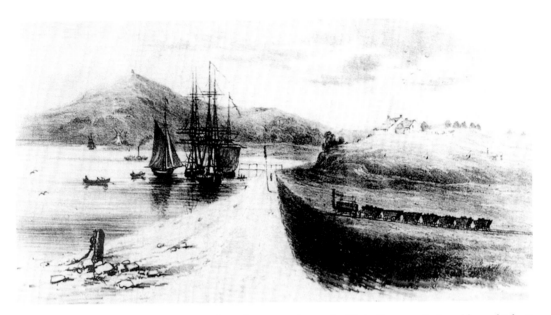

The town of Middlesbrough was originally a shipping point, to facilitate the export of coal brought from the Durham coalfields along an extension of the railway from Darlington. The new facility, completed on 27 December 1830, was part of the general development of the site after 1828, much of this being inspired by the vision of one man, Joseph Pease. The original site was part of Middlesbrough Farm, as can be seen in this contemporary drawing, which shows the farm standing on a small rise close to the River Tees and the new coal loading facility.

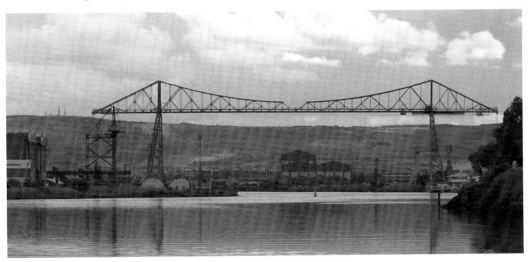

Spanned by the world famous Transporter Bridge, the same view in 2011 bears little resemblance to that of 200 years ago. The bridge, one of the only three in Britain, has a cantilever construction and is 259.3 metres in length. The river as we see it today is very different, with the influence of man and industry making it a deeper and much more navigable waterway than it ever was in years gone by. The view that we see here has changed considerably in recent decades, as large-scale heavy industry on both sides of the river has either closed or relocated. Today, the huge chimneys belching out their sulphurous smoke are long gone, and greenery has returned to the riverside. Industry remains, but only on a very small scale in comparative terms.

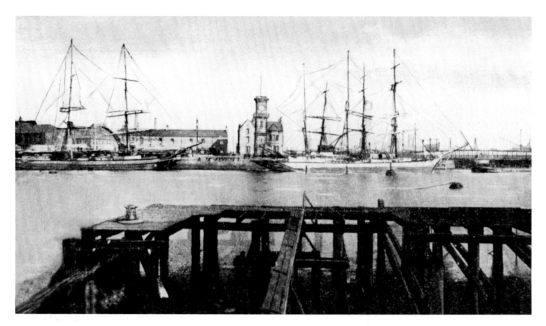

Several sailing vessels are berthed in front of the old stone Clock Tower and the row of terraced houses which stood along Dock Street around 1902. In the foreground is part of the dock. By the latter half of the nineteenth century, Middlesbrough had overtaken Stockton as the major port on the Tees; a very important factor in the industrial history of the town. Ships travelled to Middlesbrough from across the world, carrying a variety of different cargoes – a diversity which helped to nullify the cyclical economic trends in the imports and exports handled by the port.

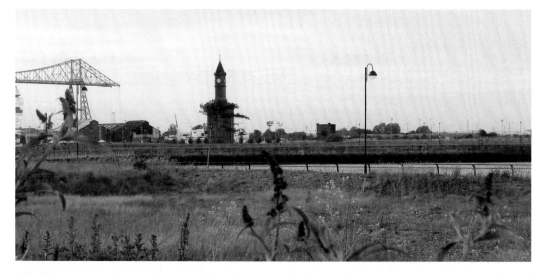

The river is much quieter today, most of the shipping trade having disappeared along with a great deal of the heavy industry that was once located along the riverside. The diminishing need for raw materials in local industry, together with the much reduced export of goods by ship, had a knock-on negative effect for trade on the river in general. Many of the staithes, which were once kept busy, are now empty – decaying reminders of an industrial heritage which is no more. The old Clock Tower is still standing, but today it is surrounded by a well-manicured area of grass rather than industrial buildings.

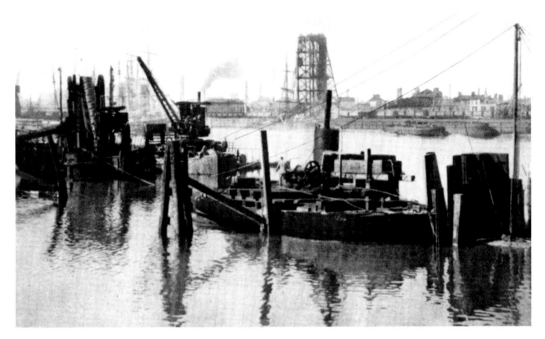

This view is quite unusual in that not only does it give a view across the river from the southern quay of the docks, but it also shows one of the partially constructed towers of the Transporter Bridge at Port Clarence. Construction is obviously at an early stage, dating this image at around 1910.

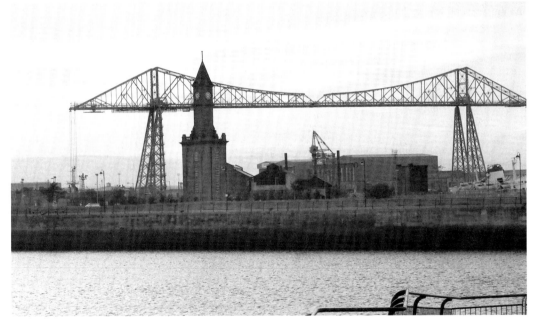

The Transporter Bridge still stands as a monument to the industrial past; an age when thousands of workers arrived at both Middlesbrough and Port Clarence to form the workforce needed for the labour-dependent heavy industries that operated at the time. Those industries, alas, are now part of that history, their contraction being one of a number of major changes that have taken place since the Second World War.

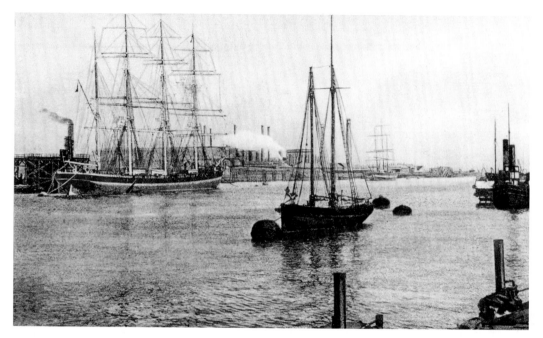

A view across to Port Clarence (*c.* 1907), showing the river banks lined with industry as far as the eye can see. Several masted ships are visible, including the four-masted vessel berthed at the staithes at Port Clarence. The distant chimneys are the Bell Brothers Ironworks. This view is taken close to the point where the Transporter Bridge was later built.

Taken from a point adjacent to the Transporter Bridge, this view illustrates the changing profile of the area. Once one of the busiest parts of the river, this is now an empty place. On the far side of the river, rotting staithes are visible close to the empty grassland that was once the site of the famous Bell Ironworks. In the foreground is the listing shell of the *Tuxedo Junction* boat, recently the subject of a lot of media attention, its plight adding to the poignancy of the riverside scene. Light industry is still to be found along the river now, but it's a far cry from the glory days when this was a world-centre of iron and steel making.

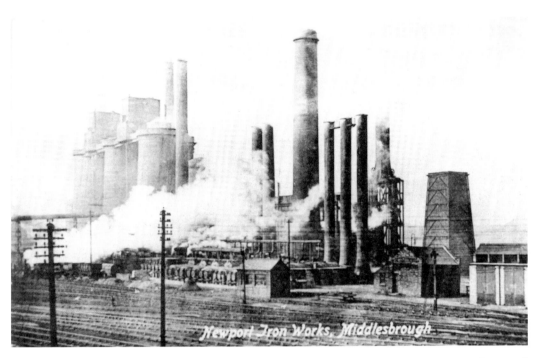

Not many years ago, the whole area looking downriver from the Newport Bridge was a mass of iron and steel works. These were built in the second half of the nineteenth century, on reclaimed marshland between Newport and the old town, the area being aptly named the 'Ironmasters' District'. The majestic ferocity of the industry can be seen here in this image of Newport Ironworks (*c.* 1912), founded in 1864, when Bernard Samuelson began calcining ironstone. This was a development that was central to the rapid expansion of the industry, which followed after local iron ore was found in 1850. In 1871, there were already seven blast furnaces operating at the works, the resultant smoke and grime pouring out over the adjacent area of housing.

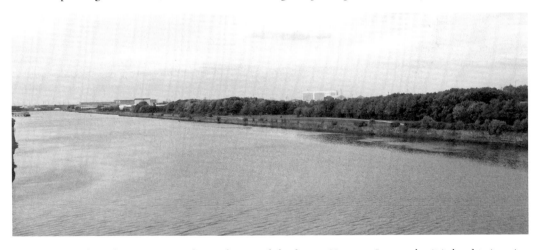

Looking today from the Newport Bridge at the site of the former Newport Ironworks, it is hard to imagine it ever existed. Not so long ago, this whole riverside location was a smoky, grimy scene with the decaying remains of a spent industry there for all to see. The river was one of the most polluted in the land. As industry retreated, the vast numbers of streets housing the workers went too. The grass has returned and the smog is a memory; fish swim up the river again. The only industry found here now is on the Riverside Industrial Park.

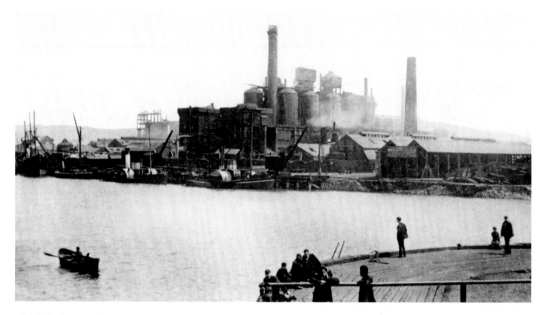

The full glory of the blast furnaces can be seen in this view (*c.* 1925) from Dock Point, which looks across to the Tees Iron Works and the Ormesby Iron Works. Following the rapid development of the nineteenth century, many smaller firms were absorbed by three major businesses. These larger companies – Bolckow Vaughan & Co., Dorman Long, and South Durham Steel and Iron Company – could compete better against the large companies abroad, particularly in America. Difficult trading conditions in the 1920s meant that Bolckow Vaughan & Co. merged with Dorman Long, making it, at that point, the largest iron and steel company in the country, with 33,000 men employed

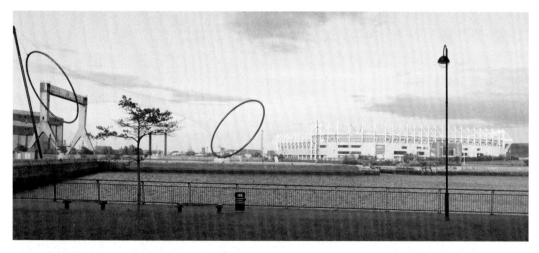

The charming wooden seats, situated on the grass verges adorning the dockside today, look onto a very different view to even that of twenty years ago. The scene is dominated by the Riverside Stadium, home of Middlesbrough Football Club, and the elliptical rings of the Temenos sculpture, a gigantic piece of art by sculptor Anish Kapoor and designer Cecil Balmond. This is part of a long-term project to regenerate the area. The hoisting of this piece of modern art, part of Tees Valley Regeneration's Middlehaven project, divided opinion, with several people concerned with the reported £2.7 million cost. Whatever your opinion is, the 45-metre-tall mast of the Temenos structure certainly stands out.

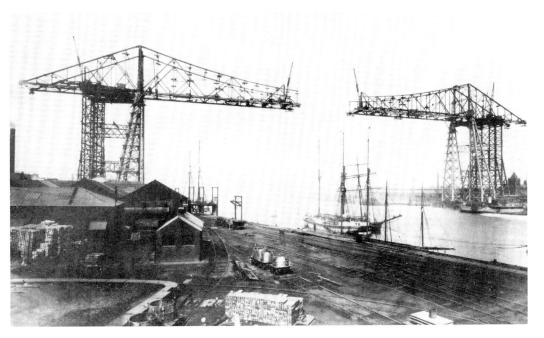

As I write these words, the Transporter Bridge is only months away from celebrating its glorious centenary. It has become an icon of Teesside, an enduring symbol of Middlesbrough's former industrial importance. When the Bill for building the bridge received royal assent, on 4 July 1907, how many people thought the bridge would still be operating a century later? Two foundation stones were laid, on 3 August 1910, by the Mayor Lieut.-Colonel T. Gibson-Poole and Alderman Joseph MacLauchlan, who had first instigated the scheme. The bridge, which cost just over £87,000 to build, can be seen here in the later days of its construction.

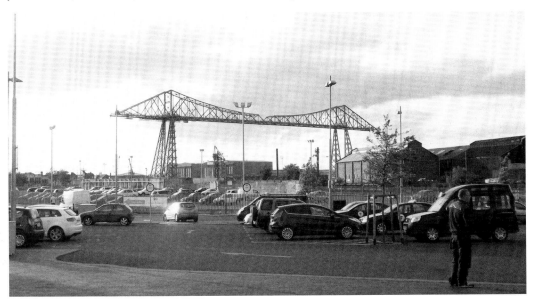

The bridge still proudly spans the river today – a link with the past; a structure which has become known across the world. This view is from the nearby car park of Middlesbrough College, one of the new developments in the area which is altering the whole profile of this location.

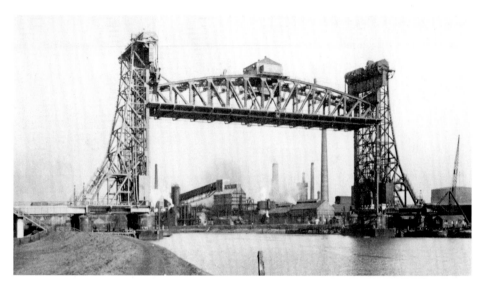

It was recognised by the early 1920s that there was a need for another bridge further upriver from the Transporter Bridge. Having decided upon a bridge at Newport, the Tees Bridge Act was given royal assent on 4 June 1930. The Newport Bridge, the first vertical lift bridge to be built in this country, was opened by the Duke and Duchess of York on 28 February 1934. Building the bridge meant the demolition of several houses in Calvert Street and Samuelson Street, as well as the buildings at Newport Station. Looking beyond the bridge, there is an excellent view of the Ironmasters District, an industrial landscape which remained largely unchanged until the 1960s.

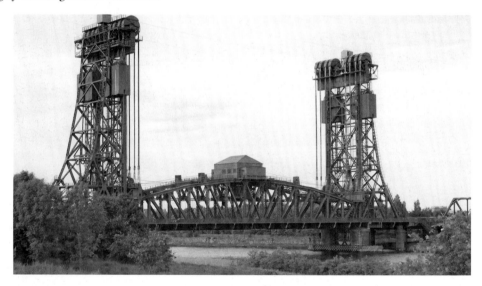

Although the road bridge is now permanently locked down, the bridge is still a remarkable construction. It is extraordinary to see two such individual pieces of iconic engineering as the Newport Bridge and the Transporter Bridge in the same geographical area. Even more amazing is to look beyond the bridge and note the successful regeneration that has returned the area back to green fields. Those who remember this area as a smoky, grimy industrial site, will appreciate just how extensive the change has been. Now wildlife lives once more in these green fields close to the bridge, as it did for many hundreds of years before when this was isolated farmland.

4

SUBURBAN DREAM

The late 1800s saw expansion southwards from the river, a development which continued
throughout the twentieth century...

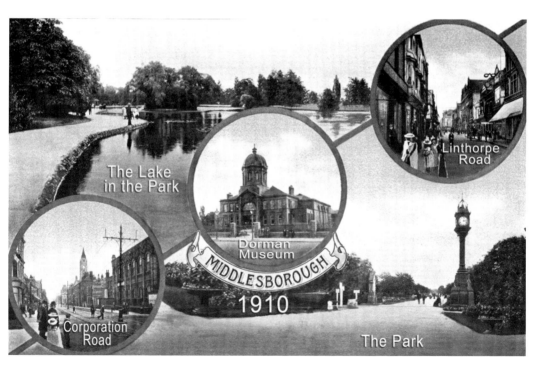

Middlesbrough in 1910, as depicted through this multi-view postcard. The town was enjoying a period of
prosperity, with iron, steel, heavy engineering and shipbuilding dominating the industrial structure at this
moment in time. The original plan for a town of 5,000 people had long been overtaken by economic and
subsequent population growth.

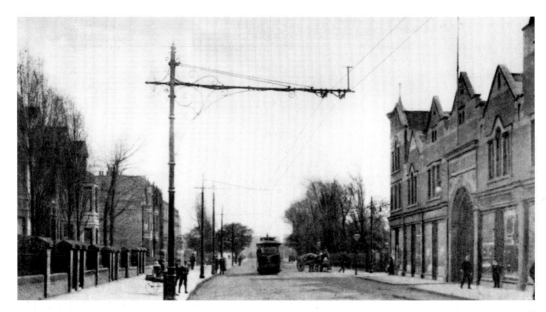

In the 1850s, as Middlesbrough expanded southwards, small pockets of land were gradually sold off for building desirable residences, for those able to afford them. Southfield Villas was built in the 1850s, North Park Road and Grove Hill in the late 1860s and Linthorpe from the early 1870s, as Middlesbrough's suburbs were born. One elegant development was Grosvenor Terrace, a group of four properties shown here on the left (c. 1905). Opposite are the Forbes Buildings, then the bakery and administrative headquarters of John Forbes Ltd. The image has an air of calm suburbia, far away from the hustle and bustle of the town. Roomy properties, with gardens, trams passing slowly by and the trees along the roadside, were a world away from the back-to-back housing over in the old town.

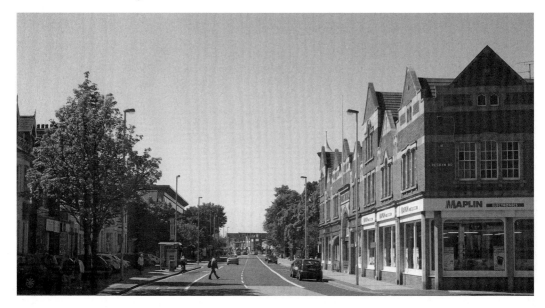

Today the buildings are still there, although little survives of the original character and prestige of these properties. The gardens have long gone; many have had their frontages altered and have become commercial properties. Forbes Buildings have now become home to a number of different businesses.

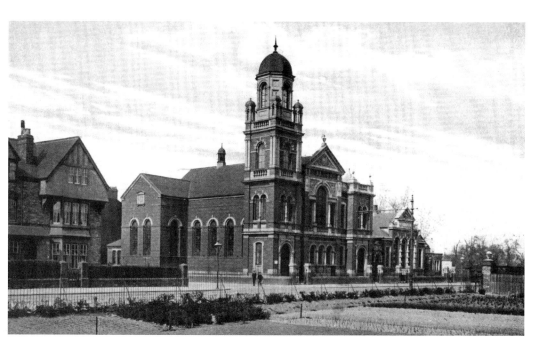

Railings surround the gardens next to the Dorman Museum in a view looking across to the Park Methodist Church, which cost £10,000 to build. Opening on 11 October 1905, it later became known as the Park Wesleyan Church, after the congregation from 'Big Wesley' joined it. Across from the church, the end house of the Victorian terrace which ran up to Kensington Road is still a residential property. The trees beyond the church line the perimeter of the old cemetery.

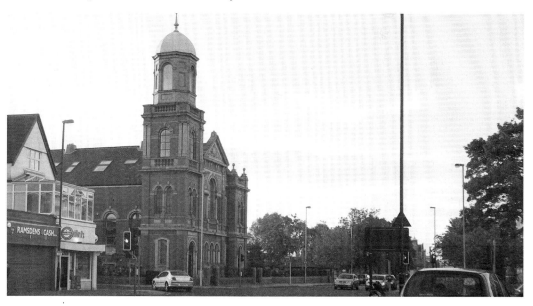

The outer profile of the Grade II listed church building remains very similar today to how it was before, although it is no longer a church, having been sympathetically converted to a small number of residential properties. It is an outstanding conversion, with no noticeable change in the exterior structure. The trees still encircle the open space next to the building, though this is no longer a cemetery.

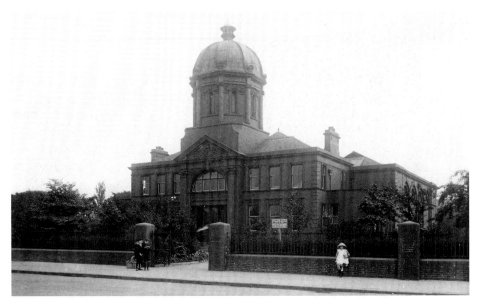

The Dorman Museum was opened on 1 July 1904, on land donated by Sir Arthur Dorman, founder of Dorman Long & Co. Ltd, as a memorial to his son George Dorman, who had died in the Boer War. The building costs of £15,000 were also donated by Sir Arthur Dorman. The museum has become well known to several generations of Middlesbrough inhabitants; the collection of stuffed animals and birds, which was donated by Sir Alfred Edward Pease, is particularly popular.

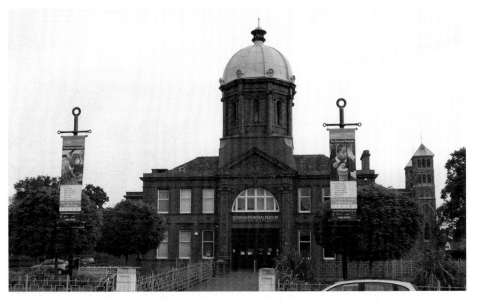

The Dorman Museum continues to be one of the leading attractions within Middlesbrough today. As can be seen, the outer fabric of the museum building remains largely the same. Inside, however, there have been numerous changes, and many of the exhibits that were familiar to several generations of visitors have been replaced by a series of modern, vibrant displays, which not only relate to the town itself but also encourage a wider appreciation of history. The immediate area around the Dorman Museum remains largely unchanged, with Albert Park, adjacent, still providing a valuable facility.

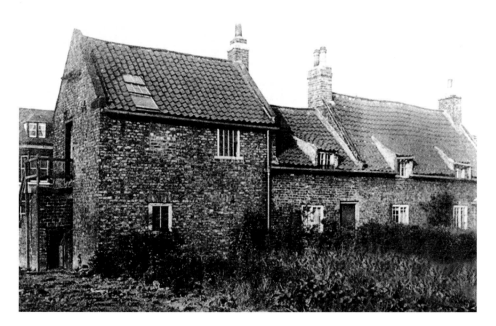

Oldgate Farm, seen here around 1902, was situated close to the site of Ayresome Park, which was built in 1903. It remained the home of Middlesbrough Football Club for ninety-two years. Back in 1902, Oldgate Farm was on the border between town and country. There was still little development west of Linthorpe Road across to Newport. The ancient hamlets of Ayresome and old Linthorpe still existed; hedgerows and trees lined the old pathways and sailors' trods that criss-crossed the open fields. Looking west from Oldgate Farm, the neighbouring farm, Ayresome Grange, could clearly be seen only four fields away.

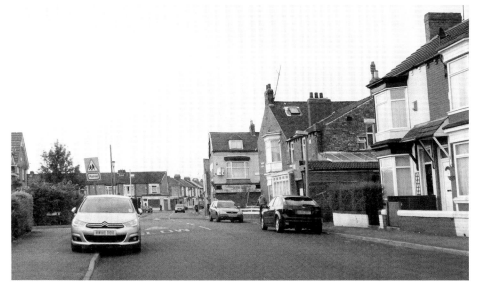

With the building of Ayresome Park football ground, however, Ayresome Park Road (seen here) was to become one of most famous in the town. Oldgate Farm was located close to the junction of Kensington Road and Ayresome Park Road, and the farmhouse actually stood close to the shop, shown here mid-picture. As the development of the town of Middlesbrough encroached southwards, the fields that had been cultivated for many centuries were swept away, to be replaced by a multitude of streets and terraced houses.

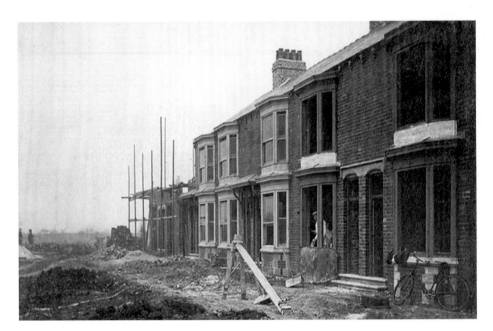

Construction is well under way here in this view taken on Clive Road (*c.* 1910). This building site was part of the development that filled the area between Linthorpe Road and Newport with the streets so familiar to us today. A joiner is fitting a window frame inside the house in the foreground, whilst in the distance two others discuss the work in progress. Beyond the housing site, there are trees and open fields on the distant horizon – evidence of the rural character the area had at this time.

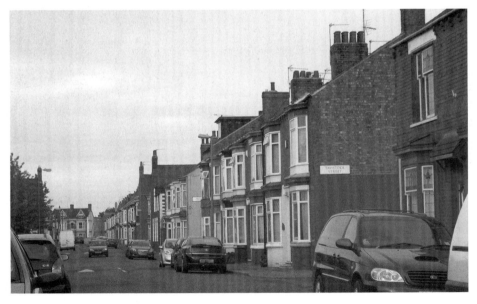

A detailed examination of the housing site in the previous image suggests that it is the row of houses, seen here in 2011, on the corner of Tavistock Street. This has been a residential area for over a century now, and despite the length of time, the houses have worn remarkably well and are still worthy residential properties today. Clive Road is known to many people as it faced northwards onto the South Stand of Ayresome Park. Today, the ground has gone and a new residential housing development has been built.

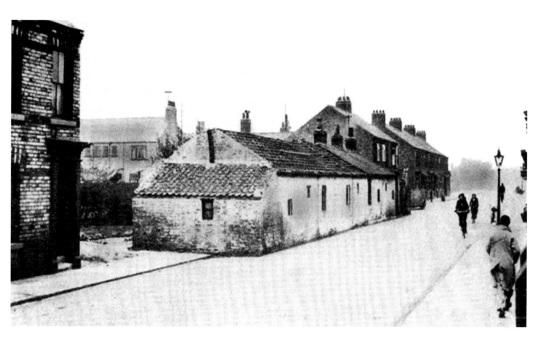

These old white cottages on St Barnabas Road were once part of nearby Old Linthorpe village. Note how the cottages stand out from the building line of the modern houses and encroach onto the modern road. At one time, the area behind the cottages was the site of an old brickyard and a pond, which was used by locals for skating during the winter months. The cottages were demolished in May 1935.

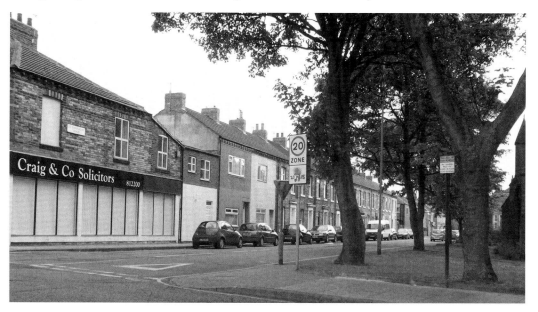

A view of St Barnabas Road today reveals few clues as to the existence of the old white cottages, but with the use of old maps it's possible to locate the site close to the junction with Megarthe Street, where the cottages once stood. The varying nature of the brickwork used for the buildings in the foreground indicates that they were constructed during different periods. On the right, the edge of the St Barnabas Church, opened in 1897, is just visible.

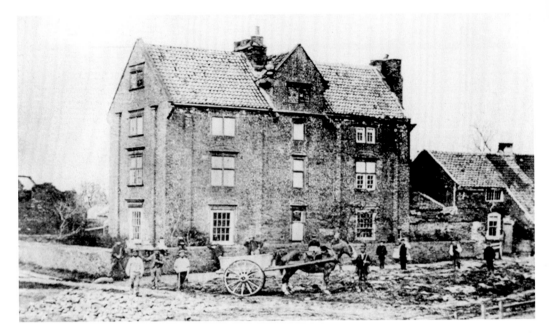

Blue Hall, Linthorpe stood east of old Linthorpe village at the corner of Burlam Road and Roman Road. The L-shaped building, with its crossed transoms and mullions of many windows, was probably built in the late seventeenth century – it features in Samuel Buck's sketch-book of 1720. Aspects of Blue Hall are seen here in around 1865. It was demolished in 1870 and replaced by a new brick residence. On 18 December 1887, it opened as a rescue home for women, under the auspices of the Salvation Army. This appears to have lasted only until 1893, when it became a private residence again. By 1925, it was unoccupied and for sale, but was eventually demolished in July 1927.

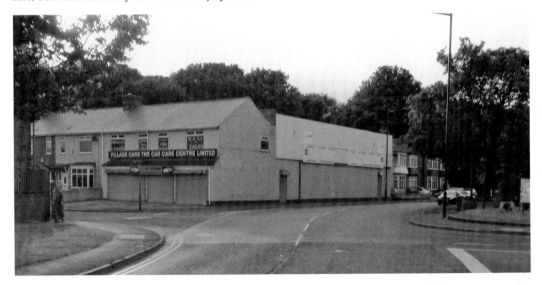

When Blue Hall was demolished in 1927, the corner was redeveloped as private housing. For many years it was the location of Shipman's Bakery. After that business was closed in 1996, it became the home of Village Cars, which occupies the building today. It is interesting to consider whether many people who pass the site now are aware of its history. The trees behind the housing are part of the New Linthorpe Cemetery.

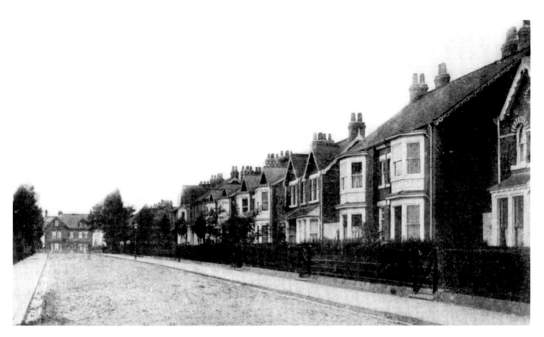

The development of the new areas of housing in Linthorpe was linked to the commercial progress of the town. Several downturns in commerce meant that the spread of the suburbs was often sporadic, and it was not uncommon for several plots of land to be found next to finished residences. This image of Sycamore Road from a hundred years ago and the ones of The Crescent and The Avenue which follow, exemplify the existence of differing styles of property within the area; a distinct contrast to the rows of identical houses found in the terraced streets elsewhere in the town.

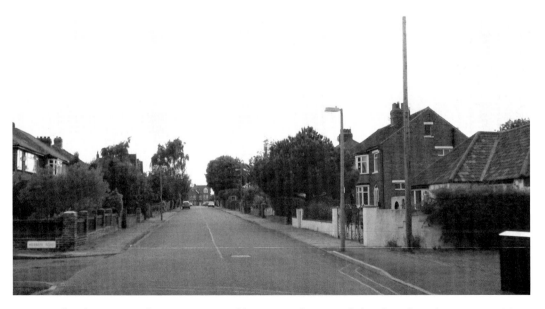

It is immediately apparent that Sycamore Road has retained its quiet feel and residential appearance. Many houses have been restored inside, but overall the appearance of the road has changed very little – even the property on Orchard Road, which faces down Sycamore Road, has a familiar exterior.

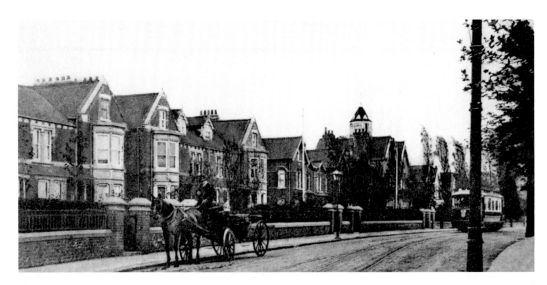

The Linthorpe area attracted many professional people able to afford a lifestyle that usually included employing 'staff' – servant girls who helped in running the house. The owners of the stylish properties shown here on The Crescent (*c.* 1907) would certainly have fitted this lifestyle profile. The development of The Crescent, from 1870, attracted some of the town's wealthier citizens, including Theophilus Phillips, Richard Scupham and T.D. Stewart, all of whom served in the capacity of Mayor of Middlesbrough. Stewart is still remembered today as the benefactor who, in 1923, gifted Stewart's Park to the town. The tower in the distance was part of Studley House and a tram can be seen approaching in the distance.

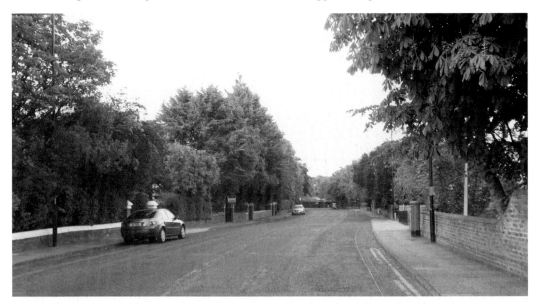

When well laid out roads like The Crescent were first built, they were on the edge of town, facing onto open countryside – an environment far removed from the smoke, grime and noise of Middlesbrough. Although now it is a part of the suburbs of Middlesbrough, The Crescent has managed to retain its air of exclusivity. Behind the trees that line the road, there are some very desirable and distinctive houses set in substantial grounds. The tram lines, still noticeable here eighty years after the service ceased to operate, are an interesting reminder of the past.

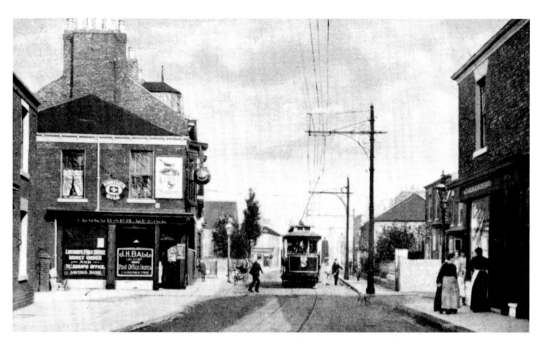

This image shows Linthorpe village around 1910, with James Henry Ball's Post Office Stores open on the corner of Chipchase Road. Local residents referred to this commercial area as 'the village' and it certainly offers a contrast to the housing found further north towards the town. The tram heading towards us terminated at The Crescent, after travelling from Ferry Road in the old town.

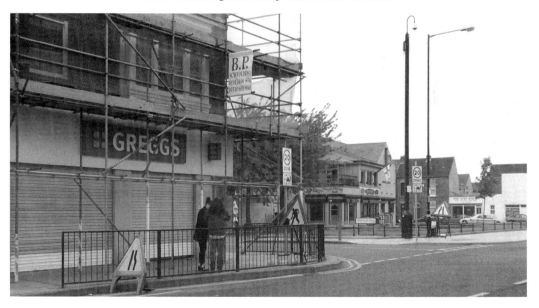

There is still a Post Office in Chipchase Road, but today it is a short distance away from the one shown in the previous image. The property where it was previously located has been demolished and the site is occupied by a leisure business. The scaffolding around the bakery shop, occupied by Greggs, detracts from the original architectural detail of the property. Although only the entrance to Stonehouse Street is visible in the older image, the street is still there today with the former Linthorpe Assembly Rooms located on one corner.

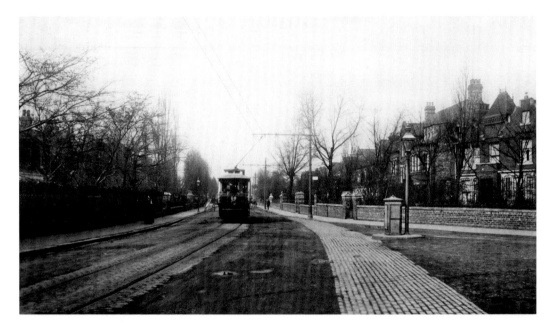

A tram approaches close to the junction of the The Crescent and The Avenue, which heads off towards the right. These impressive semi-detached and detached properties were close to New Linthorpe, known locally as 'the village'. At this time, the shops provided an essential service to the new properties in the rapidly growing suburban development. The tram service terminated at The Crescent and then ran back through town to Ferry Road.

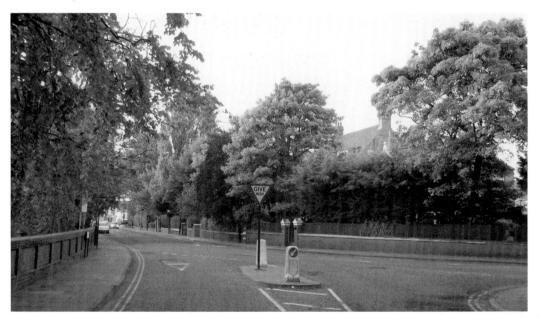

The tower on the property located in the foreground on the right, behind the trees, helps to precisely align this modern image with that of a hundred years ago. These houses are still very desirable properties, although Linthorpe village is a less distinct community than it once was. This is still a bus route, but due to the increased mobility of most people, this is a less important factor than it once was. On the left is St Mary's Care Home.

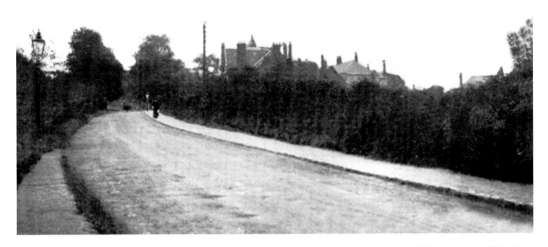

This is Roman Road in around 1908; still a country lane lined with hedgerows. Although it is difficult to be exact in locating this image, it is probably close to the junction with The Crescent, as the property in the distance is possibly Clevedon – a large detached house in extensive grounds that later became The Linthorpe Hotel. As already said, the progress of building here was sporadic; the Victorian lamp standard and partly made-up pavement shows that this road was soon to be part of a future residential development.

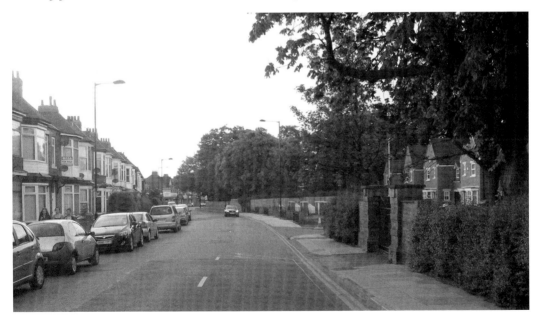

The presence of trees makes it impossible to capture a contemporary image that can be aligned with the previous one. This scene shows a residential area which has undergone some change in recent years, as one of the main buildings there, Kirby College, has closed, with a subsequent conversion of the grounds, as well as the main building, to a small residential area.

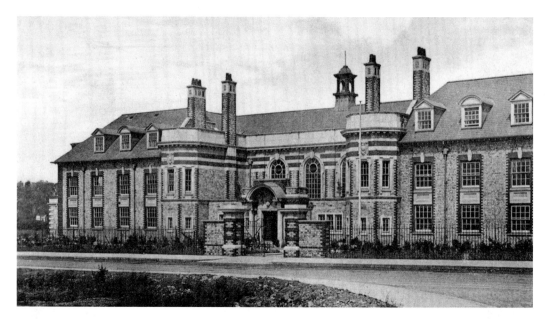

Kirby School, named after R.L. Kirby, Chairman of the Education Committee, was opened by H.R.H Prince Arthur of Connaught KG, who had earlier opened the Transporter Bridge. Troops lined the route as the Prince travelled from Albert Park, where he had planted a commemorative tree along Devonshire Road into Roman Road. A guard of honour greeted his arrival at the school. After the formal presentations and opening, the Prince was given a tour of the building before leaving for a banquet at the Town Hall in the evening, where the band of the Royal Scots Grays provided the musical entertainment. This view shows the school from the corner of Orchard Road, just after the building was completed. Note the rough land in the foreground yet to be built upon.

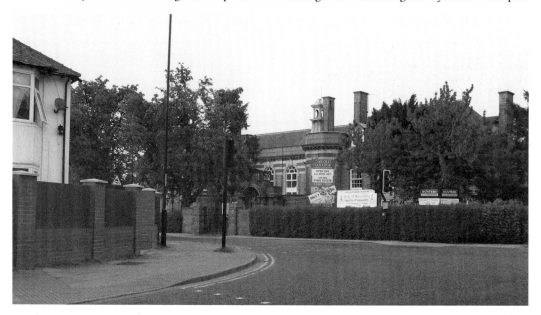

One hundred years later, Kirby School (later Kirby College) has recently closed and a residential development of the grounds, as well as the school itself, is underway. This view shows the advertisements that currently adorn the building's exterior, the development being aptly named 'The Old College'.

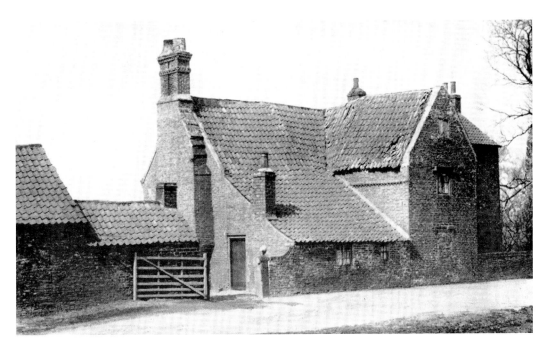

Ayresome Grange (c. 1900), a farm located to the south-east of the ancient hamlet of Ayresome, which along with the hamlets at Newport and Linthorpe pre-dated the founding of modern Middlesbrough. Those who lived at the antiquated farmhouse in its final years recall that there were no modern facilities, only basic sanitation, constant dampness, and no gas or electricity; they had to rely upon on oil lamps and candles. Standing at the farm gate, the view would have looked past the Union Workhouse towards Oldgate Farm. Having witnessed the development going on around it, Ayresome Grange was also swallowed up by the encroaching houses when it was demolished just before the start of the First World War.

This view looks across the junction of Ayresome Street and Acklam Road (Heywood Street is in the distance), towards Ayresome Green Lane and the domed tower of Archibald Primary School, where Ayresome Grange Farmhouse once stood. This is now one of the busier roads in town. It is quite remarkable to contrast this scene with the quiet country lane outside the old farmhouse.

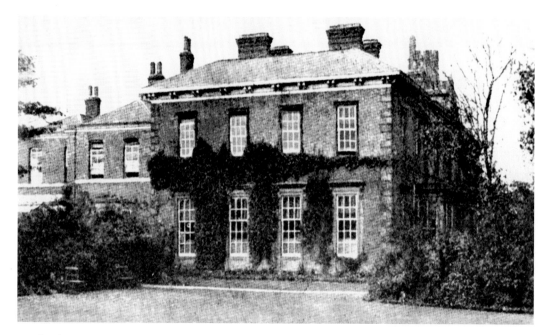

Newlands Convent, seen here around 1907, was once the home of Sir Hugh Gilzean Reid, who founded the *North Eastern Daily Gazette* in 1869. Having arrived in 1858, Reid became a prominent citizen of Middlesbrough, even editing a book to mark the town's fifty-year jubilee in 1881. In the early 1880s, Newlands was rented by the Nuns of the Faithful Companions of Jesus to be used as larger premises for the school they had recently opened. They finally purchased the building in 1896 and it became known as St Mary's Newlands Convent. The building was demolished in 1965 after the school relocated to Saltersgill.

Parts of the grounds of the Convent were sold off to be used for building, the school continuing for many years in the western part of the original site. Forty-six years after it closed, there is little evidence that Newlands ever existed; all traces of the building and the grounds have seemingly been erased – although Newlands Road, a row of terraced houses, ensures the name lives on. This view, close to the junction of Marton Road and Borough Road East, looks towards the site where the Lodge once stood in the north-eastern corner of the original grounds.

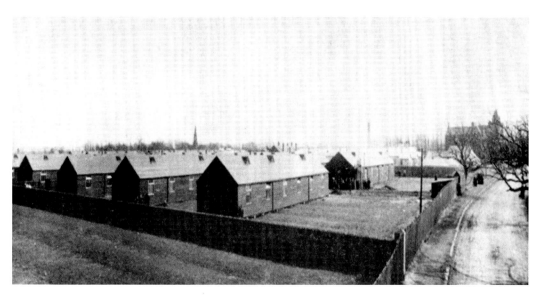

The regular occurrence of epidemics in nineteenth-century Middlesbrough resulted in 'fever hospitals' being built away from the town. In 1871, following another outbreak of smallpox, a new hospital was planned for land in West Lane, close to the New Cemetery at Old Linthorpe. West Lane Hospital, or the 'fever hospital' as it became known, opened in 1872. Dealing with cases of smallpox, typhoid and enteric fever, the hospital was extended over a further two acres in 1890, and again in 1896. A particularly virulent epidemic of smallpox in 1897–98 meant temporary accommodation had to be built to cope with the outbreak, and the huts that provided this space are shown here.

Today, following a reorganisation of the hospital facilities in the town, West Lane has a different function within Middlesbrough's healthcare facilities. The lane is a busy road, no longer out in the countryside, having become a part of the suburban landscape.

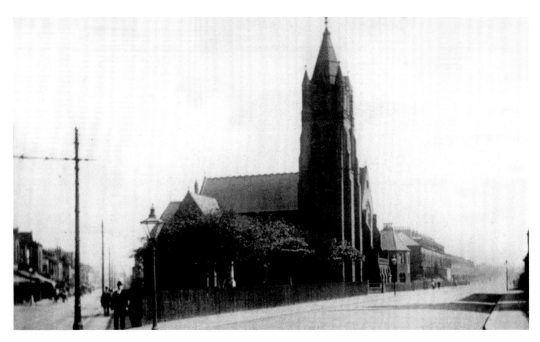

St John's Church, on the junction of North Ormesby Road and Marton Road, was consecrated on 30 November 1865, costing £5,500 to build. It is notable that many shop premises were situated on North Ormesby Road at this time.

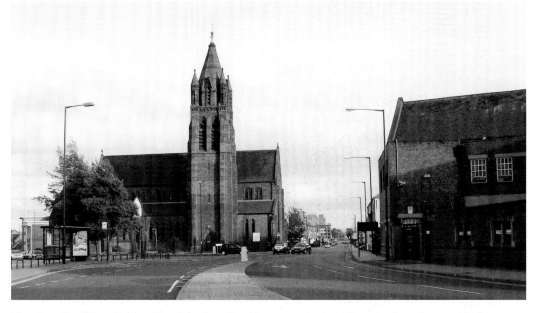

The church still stands proudly today, though many properties have been built in the surrounding area, particularly along North Ormesby Road, close to where the new A66 route is. It is quite remarkable that this church has been retained when the profile of the locality has completely changed. The church looks onto a modern cinema complex and fast food outlets; traffic is a constant background noise. Yet it survives, with weekly services still held there.

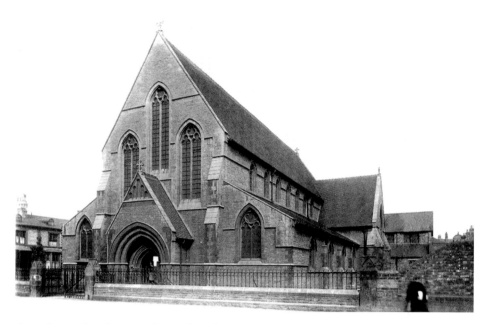

A number of new churches were built when the town expanded south of the railway, two of which still survive today. All Saints' Church, located on a site at the corner of Grange Road and Linthorpe Road, was consecrated on 20 July 1878 and became known as the 'Ironmaster's Church' because funding came from W. Hopkins and John Gjers – both ironmasters.

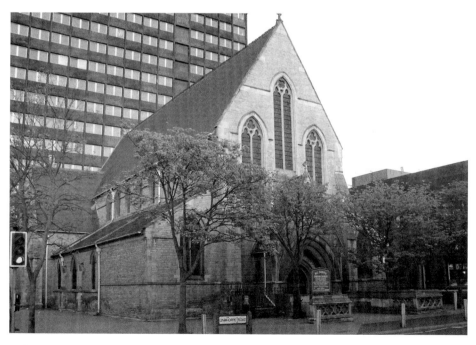

Like St John's Church, All Saints' also lives on today as a parish church in a very modern world. Surrounded by heavy noisy traffic, dwarfed by high-rise buildings and standing in a locality which has seen total change in the past forty years, the church has survived. In recent years the removal of the grime from the exterior, resulting from decades of pollution, has improved the appearance of the building.

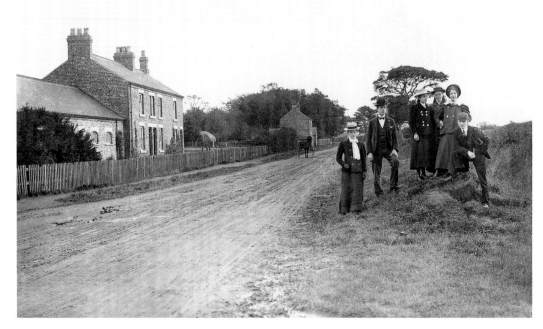

Although Middlesbrough advanced within a relatively short period of time, it was only after the First World War that this development began to reach areas like Acklam. Acklam Road, shown here around 1903, looks south to the entrances to Church Lane and what was, at that time, the old lane down to Acklam Hall. A man on a trap trots gently down the lane, and a group of people out walking pose next to the hedgerow.

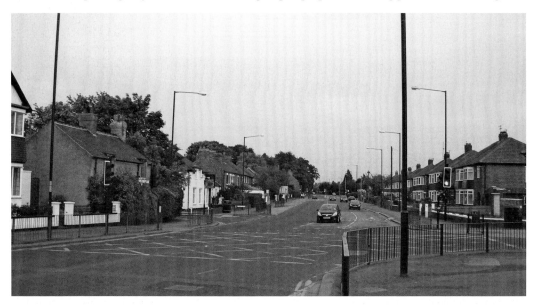

Church Lane and the entrance to what is now Hall Drive are both still visible in the distance. The houses featured in the previous image can also be picked out among the more modern properties built in the past hundred years. The changes in the surrounding area are quite remarkable, the quiet country lane having become a busy road.

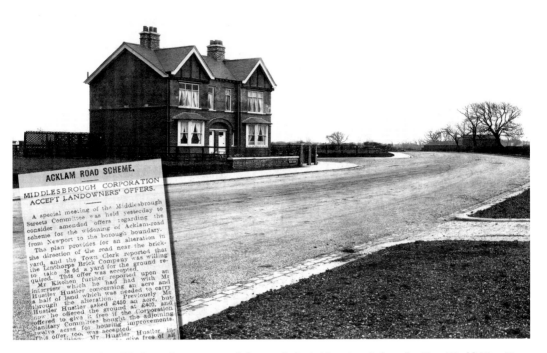

ACKLAM ROAD SCHEME.

MIDDLESBROUGH CORPORATION
ACCEPT LANDOWNERS' OFFERS.

A special meeting of the Middlesbrough
Streets Committee was held yesterday to
consider amended offers regarding the
scheme for the widening of Acklam-road
from Newport to the borough boundary.
The plan provides for an alteration in
the direction of the road near the brick-
yard, and the Town Clerk reported that
the Linthorpe Brick Company was willing
to take 3s 6d a yard for the ground re-
quired. This offer was accepted.
Mr Kitchen further reported upon an
interview which he had had with Mr
Hustler concerning an acre and
a half of land which was needed to carry
through the alteration. Previously, Mr
Hustler had asked £450 an acre, but
now he offered the ground at £400, and
offered to give it free if the Corporation
Sanitary Committee bought the adjoining
twelve acres for housing improvements.
This offer, too, was accepted. Mr Hustler in
addition. Mr Hustler ... give free of all

The boundaries of Middlesbrough were extended to include Acklam just before the First World War. Here, Acklam can be seen from closeby to the entrance of Acklam Road to Appleton Road. At this time, the year 1912, the road was in the process of being widened. In the distance are the buildings of Newport Lane Farm.

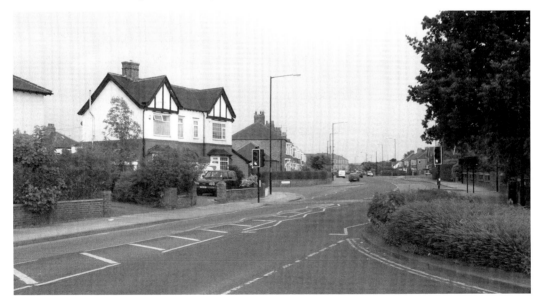

Amazingly, the house is easily recognisable today, although it is now part of a large residential area. It is quite incredible how little the exterior of the house has changed in almost one hundred years. Around the property, however, the change has been quite dramatic, particularly on Acklam Road (once a country lane), which is now a busy suburban road. Looking in the distance towards the junction with Green Lane, the distant buildings of Newport Lane Farm have all gone; the area is now part of a housing estate.

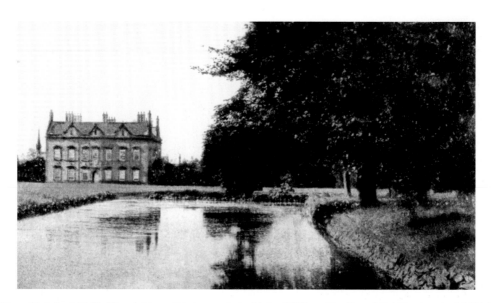

Acklam Hall (*c.* 1912). The Acklam Estate was bought by William Hustler of Bridlington in 1637. His grandson, also William Hustler, built Acklam Hall between 1680 and 1683. Originally a very formal building surrounded by elaborate formal gardens, the Hall was considerably altered in 1845, adopting a new Gothic architectural style, featuring gables and turrets with attic rooms and a new porch decorated with Gothic gables. The gardens were altered too, with large lawns laid and woods planted close to the Hall. There were further alterations in 1912. When William Hustler died in the 1920s, the Acklam Hall Estate was put up for sale. This took place on 14 December 1927, the sale of Acklam Hall following on 2 February 1928.

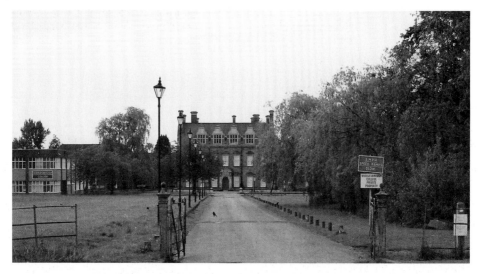

The hall was acquired by Middlesbrough Corporation for £11,500 and, after some modifications, it was opened as a grammar school for boys, taking in its first pupils in September 1935. Acklam Hall School remained open as a grammar school until 1973, when it became a comprehensive school and then Middlesbrough College in later years. Today, time has moved on again; Middlesbrough College has relocated to a new site at Middlehaven. Acklam Hall, seen here in 2011, awaits the next chapter in its long history. The building remains the town's only Grade I listed building.

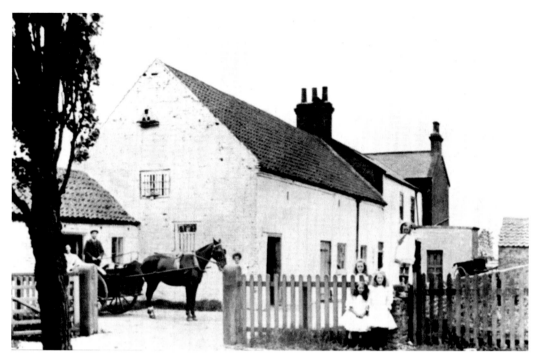

White House Farm, on the Pennyman Estate, is another of the many farms that was worked in this area in the pre-industrial era. Situated close to where King's Road and Westbourne Grove today merge as Ormesby Road, the farm was for many years tenanted by George Wilkinson and his family, some of whom are posing here in around 1900. They were the last tenants of the farm before it was demolished to make way for local development, including the building of the Majestic Cinema, which opened on 17 December 1938.

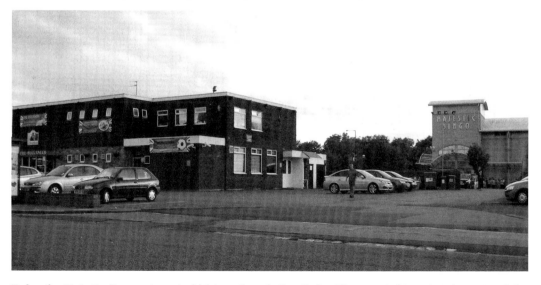

Today the Majestic Cinema is part of history, though the site is still connected to entertainment and the name lives on in the Majestic Bingo complex, which occupies the site. The Buccaneer pub occupies what was once the farmyard of White House Farm. This is a very busy road junction, far removed from the tranquil country lane that it once was.

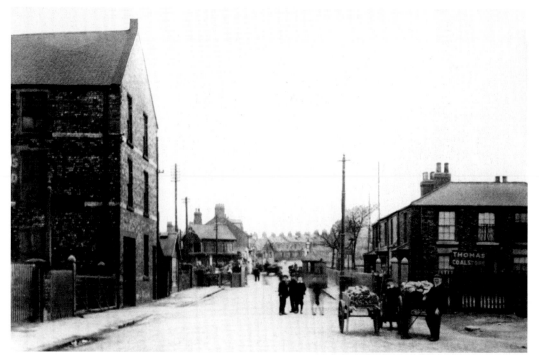

This view (*c.* 1908) looks to North Ormesby level crossing and the junction of Smeaton Street and West Terrace. The old toll bar, which operated until 1916, can also be seen located close to the signal box. The railway, which opened in 1854, originally ran from Middlesbrough to Guisborough, and later to Whitby via Battersby Junction. Two carts wait outside the coal depot on the right, whilst more carts have just passed through the toll bar.

It is impossible today to obtain an image similar to the previous one, as the routing of the A66 Trans-Pennine road has obliterated virtually all signs of the North Ormesby area. The railway to Whitby still operates, but there is no sign now of the level crossing, nor of Smeaton Street. It is almost as if it was never there at all.

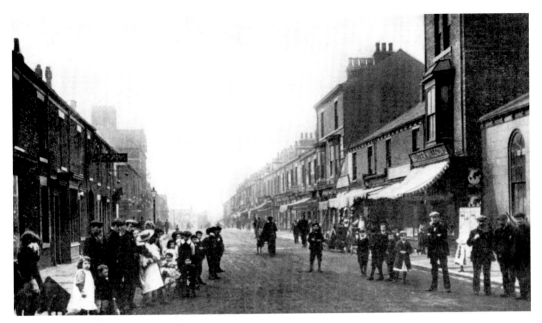

A busy Smeaton Street in North Ormesby (*c*. 1912), one of the main streets in this suburb. As we view the image, the buildings on the right are on the north side of Smeaton Street. They include an early Walter Wilson's shop. Wesleyan Chapel is further down the road on the left. Looking to the west along Smeaton Street is North Ormesby level crossing in the distance.

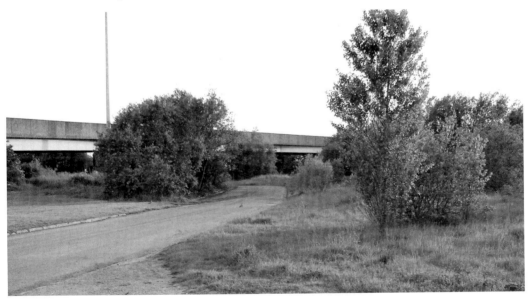

This is the closest that it is possible to get to the location of Smeaton Street, as most of it lies under the A66 Middlehaven junction. However, beyond this small section of tarmac road, which is all that is left of Telford Road West, lies the location of Smeaton Street. Many people fondly remember this area. Communities here were close knit and, living in such proximity, people developed lifelong friendships. One curious point is that the local name for the area around Smeaton Street was 'Doggy' – and though there are many plausible theories, no one is really sure why this name came about.

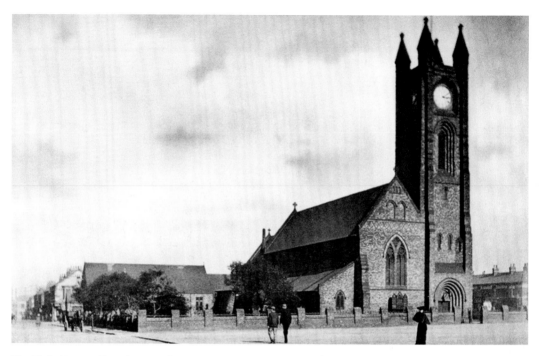

The Holy Trinity Church in Market Square, North Ormesby (*c.* 1908). Standing on the corner of Charles Street and the Market Place, Holy Trinity Church was consecrated on 26 November 1869. It has had various extensions, including the addition of the tower in 1880 and the clock in 1883.

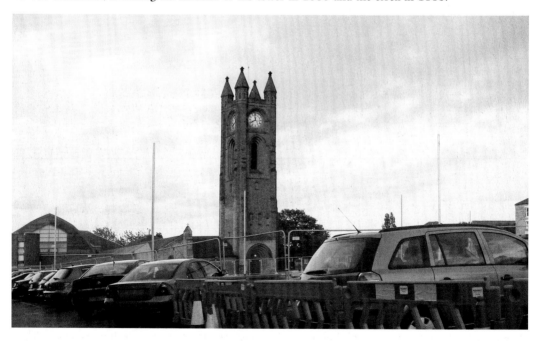

Holy Trinity Church still stands today, though most of the immediate area has either been completely demolished or changed beyond recognition. The Market Square was once the hub of the suburb, but today, with the destruction of the residential areas, it is no longer the centre of the community.

5

SOME HIGHLIGHTS

A few events from the many that have taken place in the years gone by…

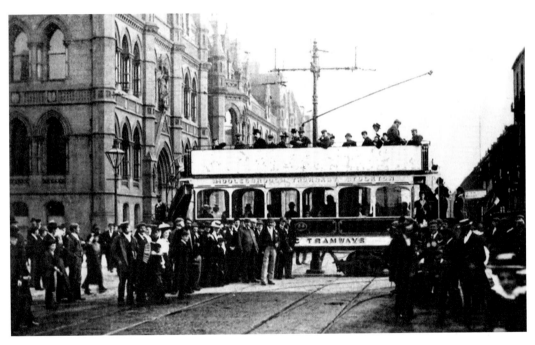

In 1897, a Parliamentary Bill sanctioned the building of an electrified tram system from North Ormesby to Norton Green. As new tracks were laid, the end was pending for the horse-drawn services; the last horse-tram service from the Exchange to Newport ran on 13 December 1897, and on the route to Linthorpe a week later. The new service began operations on 16 July 1898, bringing one of the most up-to-date systems of the time to the town. This image shows crowds around a vehicle at the intersection of Albert Road and Corporation Road. The destination board shows the new route. Despite only having wooden seats and giving a fairly bumpy ride, the electrified tram service was very successful, enabling many ordinary people to travel much further than before.

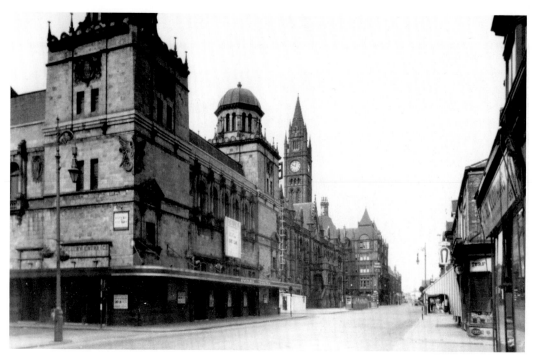

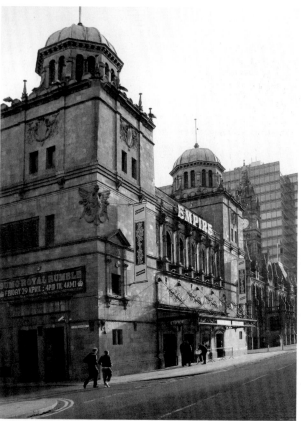

Above: The Empire Palace of Varieties, shown here, has a distinctive history stretching back to the days of the Music Hall. Built on a site previously used for circus shows, the Empire had six private boxes and other seating for more than a thousand people. Many famous entertainers have appeared at the Empire since it opened on 13 March 1899, including Charlie Chaplin, Stan Laurel, Gracie Fields, George Formby, Will Hay, W.C. Fields, Marie Lloyd and Morecombe & Wise. In 1937, Sir Harry Lauder, returning to the Empire after an absence of thirty-three years, paid tribute to the 'spirited nature' of the audiences there.

Left: The Empire Theatre, as it is now known, has transgressed generations of entertainment and today is still a popular venue with young people, who flock to the disco entertainment provided there. The Empire still attracts well-known names from the entertainment world, including Pete Tong, Tiësto, Paul van Dyke, Roger Sanchez, the Darkness, Razorlight, Arctic Monkeys, Kaiser Chiefs, Kasabian and Scissor Sisters.

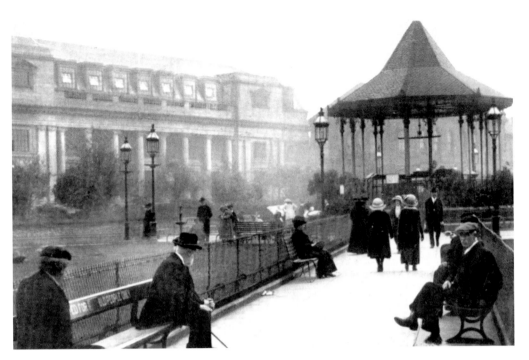

This is a fascinating view of Middlesbrough before the First World War, showing Victoria Square and the newly opened Carnegie Library behind it. There are so many points of interest here: the well dressed people walking towards the ornate bandstand; the men sat watching the world go by; the sign that says the seats are for old people only; and the children in period dress in the background. All these details add to the very pervasive period atmosphere.

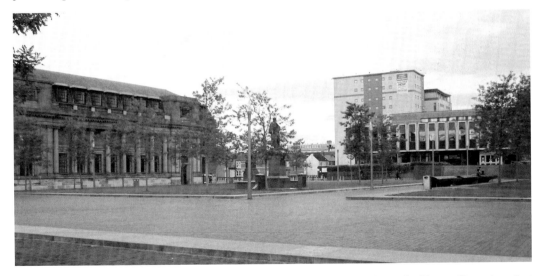

The same view today lacks the atmosphere of the previous scene. The library building still survives, but Victoria Square is now merely an open space with seats and some rectangles of grass. The past isn't always better, but the renovation here has transformed the area into a place that lacks the distinction of the previous design. One point to note is that beyond the library, original (renovated) terraced houses still exist in Montrose Street and Boswell Street among others.

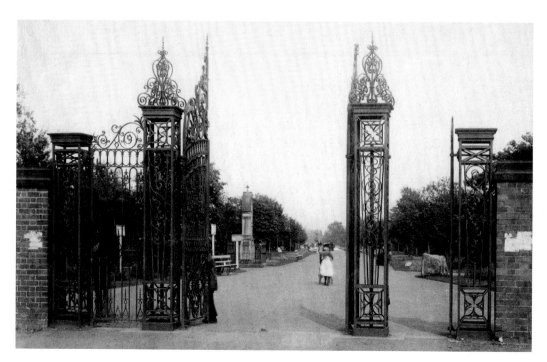

Many thousands of visitors went to Albert Park each year; this image shows the magnificent Park Gates in 1896. Beyond the Park Gates is Wellingtonia Walk, one of the main routes through the park. The first main entrance gates, which are shown here, were on the west side of the park and facing Linthorpe Road, having been made by Walker's of York and purchased for donation by Henry Bolckow at an exhibition in York in 1867. The elegant clock was presented by Alderman Thomas Sanderson in 1900.

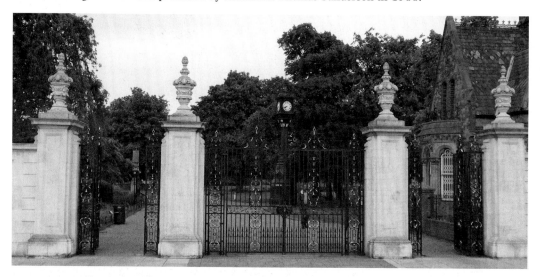

The original gates have not survived the passing of time, but the present gates, which have been in place since 1982, are a worthy replacement and do not detract from the stylish entrance to the park. The clock has been more fortunate and still stands close to the entrance. Part of the West Lodge can also be seen. Albert Park today is still a wonderful facility; a recent restoration project has ensured that it will continue to serve as a vital leisure facility for many years to come.

Toll Bars had been erected in the nineteenth century on all privately owned roads. Although some had been abolished before 1914, an Act was passed abolishing the five that remained in the Middlesbrough area from 31 July 1916. A commemorative programme accompanied the formal ceremony, bringing an end to the toll bars. A pony and trap passes through the toll bar on Marton Road, with the toll bar cottage visible behind the hedgerow. Notice the state of Marton Road, at this time just a narrow country lane.

The toll bar cottage on Marton Road still stands nearly a century later, but is no longer on the perimeter of the town. Of course this is now a busy road into Middlesbrough but the survival of the cottage is a reminder of a time before the age of modern motoring.

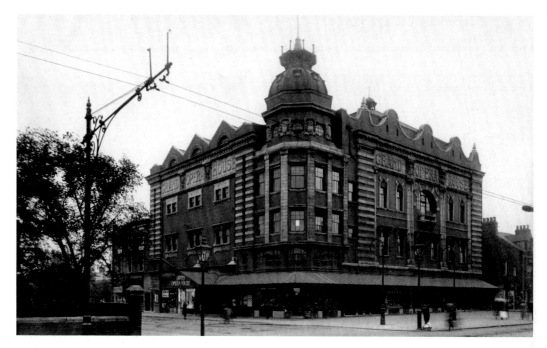

Another well-known venue that carried on the tradition of entertainment, established in the old town during the nineteenth century, was the Grand Opera House. Built at a cost of £38,000 on the corner of Southfield Road and Linthorpe Road, previously the site of Swathers Carr, the Opera House opened on 7 December 1903. Many famous artists played there, including Charlie Chaplin in 1912 (with Fred Karno), Gracie Fields, and Jack Buchanan. It closed on 21 June 1930 and reopened on 31 March 1931 as the Gaumont Cinema.

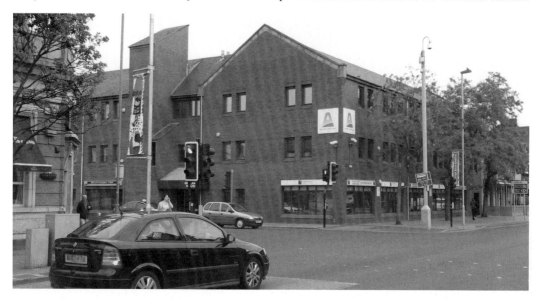

Today there are few signs that the elegant opera house ever existed. The Gaumont Cinema survived until 1963; subsequent development has included the building of the new structure that stands on the site today. Much of Southfield Road has gone too. It is strange to think that when this site was part of Swatters Carr Farm it was open countryside. In 1879, the Cleveland Agricultural Society held their annual show here.

Ayresome Park was the home of Middlesbrough Football Club from 1903 to 1995, when the club decided to move to their current home, the Riverside Stadium. This view of the ground from Ayresome Park Road is taken in 1995, on the occasion of the final game at the ground. Crowds of supporters, aware that this is a historic occasion, are milling around the East Stand.

When the ground closed, it was sold off to become a housing development. This view is taken from the same perspective as the previous image, and shows the houses which now stand on the site of the old East Stand. The roads have all been given football related names, including The Turnstile (shown here), The Midfield and The Holgate (named after one of the stands at the former ground).

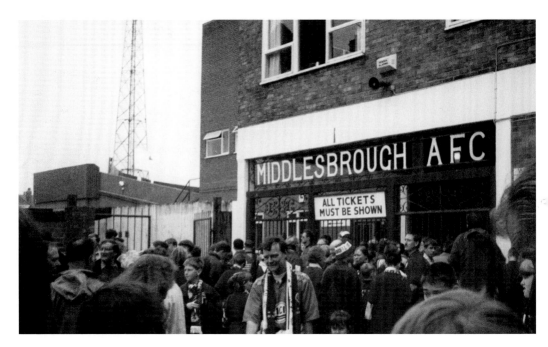

Here we see another scene from the day of the final game in April 1995. It shows the entrance to the North Stand, the oldest roofed stand, with the iron gates to the club visible. They became synonymous with the resurrection of the club when it came close to going out of existence in 1986, and a famous image of the Official Receiver opening the gates to the club marked the end of the threat to close the club down.

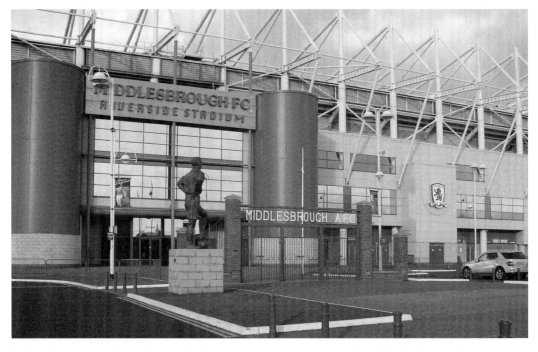

Today, the gates stand proudly outside the main entrance to the new Riverside Stadium and have become a point of homage for many supporters, who regard them as a permanent link to the Ayresome Park era.

6

WHEN SUBURBS
WERE VILLAGES

Over a period of more than a hundred years, Middlesbrough engulfed neighbouring
villages that had been around much longer…

This shows Raymond Wilkinson ploughing in the spring of 1947. The distant clump of trees
was located east of the farm, close to Ormesby Road. One or two of these trees still remain today
as a natural feature of the housing estate.

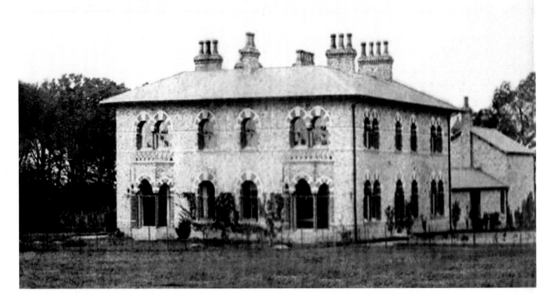

Park End House was situated at the southern end of Ormesby Road, in grounds that faced Ormesby Hall. This image is from around 1890, when the area was open countryside and Ormesby Road was a narrow country lane.

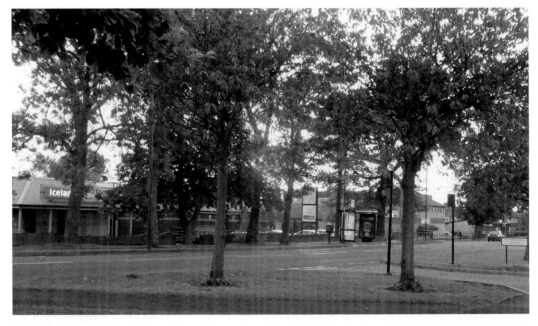

Today, the site of Park End House is a supermarket – a remarkable contrast to the previous image, and one that exemplifies the area's development from a place of rural tranquillity to one of busy suburban life. It is always tempting to wonder if people who once occupied a property would recognise the modern-day view of their homes; but surely the former residents of Park End House in 1890 could never have envisaged the change that has occurred.

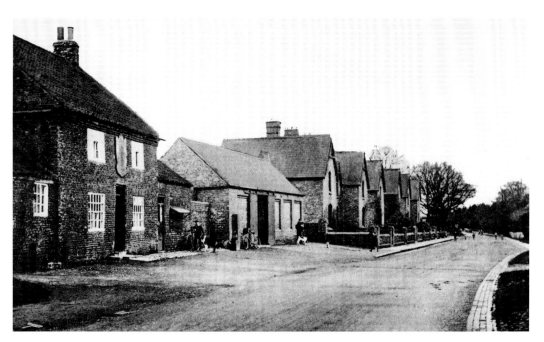

Marton was one of several long-established agricultural communities on the ancient route from Yarm to Guisbrough. Marton, thought to come from the word 'mere' (marsh) and 'ton' (town), is mentioned in the Domesday Survey. Owned for several centuries by the Lowther family, it was sold in 1786 to Bartholomew Rudd of Marske, whose family owned the land at the time when Middlesbrough was built in 1830. The Rudds Arms, a public house in the village, is shown here in the left foreground.

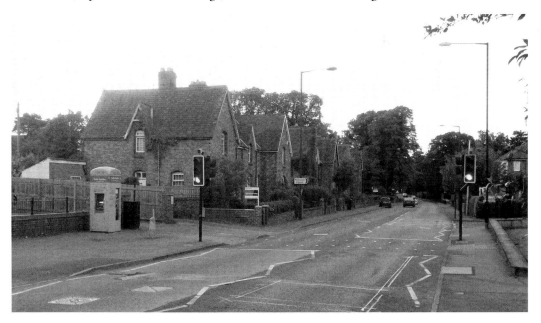

The Rudds Arms still trades, but the building has changed completely and no longer fronts directly on to Stokesley Road. However, the houses to the north of the pub are still there, and as we look toward them the scene is very familiar.

During the early 1900s, an increasing number of inhabitants of Middlesbrough took up cycling and walking. Ormesby Bungalow, along with nearby Marton Bungalow, became popular local venues to visit. Ormesby Bungalow grew to be very much the heart of village social life, with many well-attended dances held there. This image of Ormesby Bungalow (*c.* 1910) captures the rural surroundings at that time, in the years before the First World War.

A garage occupies the site of Ormesby Bungalow now, which fronts on to a very busy suburban road. There are still many people who remember the bungalow but, in common with many aspects of life in the old village itself, Ormesby Bungalow has been consigned to history.

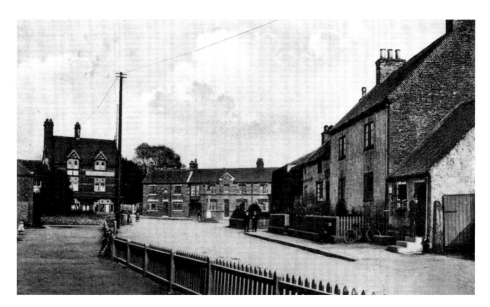

Ormesby was mentioned in the Domesday Survey, with various families owning land here, including Robert de Brus, the Percys of Northumberland, the Conyers, and the Strangeways, before the long-standing association with the Pennyman family began in the late sixteenth century. This view shows the village from the west (*c.* 1900), with the eighteenth-century almshouses on the left. Despite the rapid expansion of nearby Middlesbrough, Ormesby retained many of its village features well into the twentieth century, due, mainly, to the conservative stewardship of the Pennyman family.

Modern Ormesby incorporates, in architectural terms at least, aspects of both the past and the present. In this contemporary view, several buildings remain similar in their appearance compared to a century earlier, including the almhouses on the left, the housing at the start of Church Lane (mid-distance) and, on the right, the large property adjacent to the road. However, many physical features of the old village have gone, including the cross that stood on Church Lane and Ormesby Bungalow, now occupied by the petrol station, as seen here in the distance. Perhaps the greatest changes are out of shot, as this once distinct and quiet country community has been absorbed into the hustle and bustle of urban Middlesbrough.

BIBLIOGRAPHY

Books

Bass, B., *Rudds of Marton* (Earth-Net Communications, 2001)
Bell, Lady Florence DBE, *At The Works* (Arnold, 1907)
Hempstead, C.A., *Cleveland Iron and Steel Industry* (British Steel, 1979)
Horton, M., *Story of Cleveland* (Cleveland County Libraries, 1979)
Kirby, R.L., *Ancient Middlesbrough* (Woolston, 1899)
Lillie, W., *History of Middlesbrough* (Eyre & Spottiswood, 1968)
Mathews, A.D., *Acklam Hall: House and History* (1987)
Menzies, P., *Cleveland in Times Past* (Countryside, 1987)
Menzies, P., *Around Middlesbrough* (The History Press, 2010)
Moorsom, N., *Middlesbrough As It Was* (Hendon Publishing, 1983)
Moorsom, N., *Book of Middlesbrough* (Barracuda Books, 1986)
Polley, L., *The Other Middlesbrough* (University of Teesside, 1993)
Roberston, W., *Middlesbrough's Effort in the Great War* (Jordison, 1924)
Stephenson, P., *Central Middlesbrough*, vols 1–3, (Middlesbrough Reference Library, 1999–2003)
Stephenson, P., *Linthorpe Road and Linthorpe Village* (Middlesbrough Reference Library, 2000)
Tomlin, D.M., *Past Industry along the Tees* (A.A. Sotheran, 1980)
Waterson, E. & Meadows, P., *Lost Houses of Yorkshire and the North Riding* (Raines, 1990)
Woodhouse, R., *Empire Theatre 1897–1987* (Middlesbrough, 1988)
Woodhouse, R., *Middlesbrough: A Pictorial History* (Phillimore, 1989)
Woodhouse, R., *Stockton: A Pictorial History* (Phillimore, 1990)

Articles

'Middlesbrough Jubilee', *Illustrated London News*, 8 October 1881
'Middlesbrough Football Club', *The Lantern Magazine*, April 1895

Other Sources

Ancestry website: www.ancestry.co.uk (Births, Marriages and Deaths Index; Census Records 1841–1901)
Cleveland and Teesside Local History Society: History of Middlesbrough in maps (Middlesbrough, 1980)
Evening Gazette (Teesside), various editions 1899–1968 (available on microfiche at Middlesbrough Reference Library)
Middlesbrough Extension Map, 1856 (held at Teesside Archives)
North Ormesby History Group, 1999– 2001, 'Windows on the Past'
Smallwood Album US742 (held at Teesside Archives)
Stockton and Teesside Herald, various editions 1919–1940 (on microfiche at Middlesbrough Reference Library)
The Times, Online Archive (1785–1985)
Tweddle, G.W. 'Notes of the History of Middlesbrough 1881', unpublished
Various oral interviews conducted between 1978 and 2008

In addition, a large number of trade directories for County Durham and North Yorkshire, covering the period 1828–39, have been consulted and used to provide and verify information.